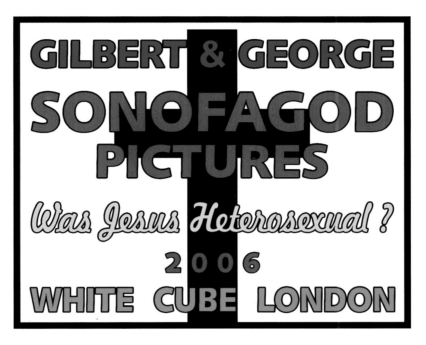

GILBERT & GEORGE
SONOFAGOD
PICTURES
Was Jesus Heterosexual ?
2006
WHITE CUBE LONDON

SONOFAGOD PICTURES 2005

Was Jesus Heterosexual?

'– leaving his colleagues to indulge in empty verbiage, he pressed forward his investigations in other directions, for he was bold enough to aim at storming God in His most secret strongholds.'
André Gide; *The Vatican Cellars* 1914

'We think every single person is religious, to a certain degree. That's what we are, as well. We try to sort out what that means.'
Gilbert & George 1986

Lustrous, ornate, pictorially complex, vividly coloured, yet suffused with tenebrous solemnity, the *Sonofagod* pictures have all of the dramatic visual impact which one might expect to find in neo-Gothic medievalism – in Victorian reclamations of Celtic or Moorish symbolism, for example, regally bejewelled and portentous with romantic mysticism. At the same time, however, the *Sonofagod* pictures possess a darkly graven strangeness, at once archaic and ultra-modern, in which their temper no less than their signage appears deeply contemporary, ritualistic and disturbed.

Gilbert & George attach particular importance to the titles of their pictures, and those of the *Sonofagod* pictures seem almost drawn from some futuristic slang: *Eesa, Base, Dote, Free Fall, Rank, Basket, Mufti*. Some are taken from Islamic sources (*Eesa*, for example, means 'Jesus'), while others suggest a suburban English quaintness – *Pixie Hill* or *Good Luck*.

The title of the biggest picture of this group, *Was Jesus Heterosexual?*, also includes two lines of text, running along the top and and bottom of the picture. 'Jesus says forgive yourself / God loves fucking! Enjoy'. In keeping with the extensive use of texts, words, slogans and found anonymous writings in the art of Gilbert & George, these pronouncements are in fact quotations from graffiti. In the context of these pictures their sense seems simultaneously feckless, mischievous, enlightened and mad – all qualities which might describe the visual language of the entire group of *Sonofagod* pictures.

This mixture of the sacred and profane, ancient and modern, coded and explicit, opulent and debased, ornate and horrific, seems central to the sustained force of these pictures on religious subjects. Gilbert & George appear within some of the pictures – *Akimbo*, for example, and *Basket* – as remote, blurred, unreachable figures. They seem to gesture or pose, ghost-like, from beyond a gauze-like membrane in the depth of the picture. This serves to sharpen even further the extravagant imagery in the foreground. Elsewhere, Gilbert & George appear in the halved, doubled, reflected versions of themselves – at once impassive and possessed, human and allegorical, their appearance punning, perhaps, on the dual nature of their single identity as an artist.

But the principal imagery of these pictures is taken from a widely eclectic, multi-denominational and multi-cultural range of religious and superstitious symbolism. Islam, Free Masonry, national insignia, Catholicism and Judaism are all represented, as well as an array of folk-loric charms: imps, horseshoes, wishbones, prayer medals, lucky amulets.

Bifurcated, reflected down their centres, fused together, mixed, mutated, and crowded into a single, seemingly deafening chorus of beliefs, these emblems become a visually dense patterning of blasphemous iconography. Debased through their transposition into grotesquery, the mutant tokens of this polytheistic anarchy confront us from shadowed half lights of scarlet, royal blue, emerald and gold – the hues of which are at times so rich that they seem to have a poisonous glow.

The styles and materials of these amulets and devices are suggestive of all the pomp and splendour that one might associate with both institutional ornament, and the plain or semi-precious extravagance of cheaply acquired lucky charms. Together they present a single texture – neither Godly nor godless, but a vast, heterogeneous patterning of pietistic insignia, at once intricate and foreboding. This is no single attack upon a single faith, but seemingly a rounded denouncement of belief in deistic or supernatural power per se. The array of religious cosmology appears in a state of deranged, confused and debased anarchy – its symbolism becoming a lurid pageant of absurd, impotent monsters, rococo in its extravagance.

But the art of Gilbert & George has always been steeped in religious and sacred imagery, as much as it is rooted in the signage and symbols that one could find without difficulty in almost any modern city on Earth. They have presented this imagery as it finds its place as a vital informant of the individual and social experience of being alive in the modern world.

In this much, Gilbert & George have viewed religious and folk-loric symbolism as part of a much greater vision of signs and tokens. Crosses and swastikas, sacred texts from the Bible or the Koran, nature and prayer, are seen alongside graffiti or political leafleting, coinage, magnified bodily substances, vistas of buildings or the faces of strangers.

And yet the sacred and the secular seem always to exist within the art of Gilbert & George as both ambiguous and interchangeable. In pictures from the 1980s, for example – *Black Church Face* (1980), *Life Without End* (1982), *Youth Faith* (1982) – we find directly Christian imagery and attitude within the pictures, but seemingly re-positioned to present what Robert Rosenblum has described as 'new versions of religious truths and passions – a universe of burgeoning nature and beautiful male youths', amidst which Gilbert & George, 'kneel and pray to their own creation.'

In the epic quadripartite picture *Death Hope Life Fear* from 1984, the imagery and composition appears less Christian in its imagery and more reminiscent of Indian tantric art; but the monumental pictures which comprise the four appear ceremonial and ritualistic – almost as though each picture was in one sense a guardian image to some manner of theological text.

And yet again, from the *New Testamental Pictures* of 1997 (the title itself being perhaps a pun on the Biblical sense), we see in *Sodom*, *Spit Law* and *Eat and Drink*, the corporeality of Gilbert & George at its most vulnerable and intense, set against reproduced religious texts relating to sexual behaviour. As such, we can see how the *Sonofagod* pictures advance and consolidate a major theme and a crucial emotion – our individual and collective relationship to religion and superstition – within the art of Gilbert & George.

But there is a renewed intensity to the imagery within these pictures, which fills them with anger and horror; their mood is one of indictment and rebellion, an assault on all the laws and institutions of superstition and religious belief. As such, the *Sonofagod* pictures might be regarded as comprising the ecclesiology of aggressive agnosticism.

In *Mass*, for example, we see the figures of Gilbert & George, simultaneously halved and reflected down their centres (the effect seeming to etiolate their bodies) quite surrounded by a profusion of crucifixes and crosses. The figures of Christ upon the crucifixes are also halved and reflected down their centres, making a deformed shape which is at once monstrous and reminiscent of a splayed carcass. In their turn, these crucifixes (there are twelve – one for each panel of the picture) are set amongst further crosses which appear almost layered on top of one another, as though creating a tessellation of partially overlapping religious medals. The effect is both horrific and opulent, just as *Give It Up* and *Crosswise* appear to echo the visual luxuriance of some Roman Catholic decoration.

Elsewhere, obscenely divided 'lucky pixies' leer out at the viewer from *Heterodoxy*, while the figures of Christ upon the Cross appear skeletal and defaced, the upper body cowled within bejewelled horseshoes which are themselves inverted. In traditional folk-lore, to hang a horseshoe above the door was good luck, but to hang it inverted would bring bad luck. The figures of Gilbert & George stand within *Heterodoxy*, reflected down their centre, green suited, their expression simultaneously intent and vacant, all-knowing and unknowable. Around their heads are the faint, luminescent spheres of aureola, suggestive of holiness or sanctity.

In many ways, these *Sonofagod* pictures are perhaps the most violent which Gilbert & George have ever created. They present religions and superstitions as evil in themselves, their laws and institutions nothing more than the enforcers of fundamentalism, prejudice, persecution and tyranny. And it is against such dogma and cruelty that these pictures declare their forceful antagonism. As such, we could see the 'anti-religious' fervour of these pictures as being in the lineage of Baudelaire's 'blasphemous' writings from the middle of the nineteenth century – specifically his *Fleurs du Mal* and *Journaux Intimes*. In a critical essay on Baudelaire written in 1930, T. S. Eliot observed: 'But actually Baudelaire is concerned, not with demons, black masses and romantic blasphemy, but with the real problem of good and evil…' A pronouncement endorsed by Christopher Isherwood's statement in 1949 that Baudelaire was 'a deeply religious man, whose blasphemies horrified the orthodox…'

The same might be said, perhaps, of these disturbing, revolutionary, morally complex pictures, and of the artists who have created them.

Michael Bracewell

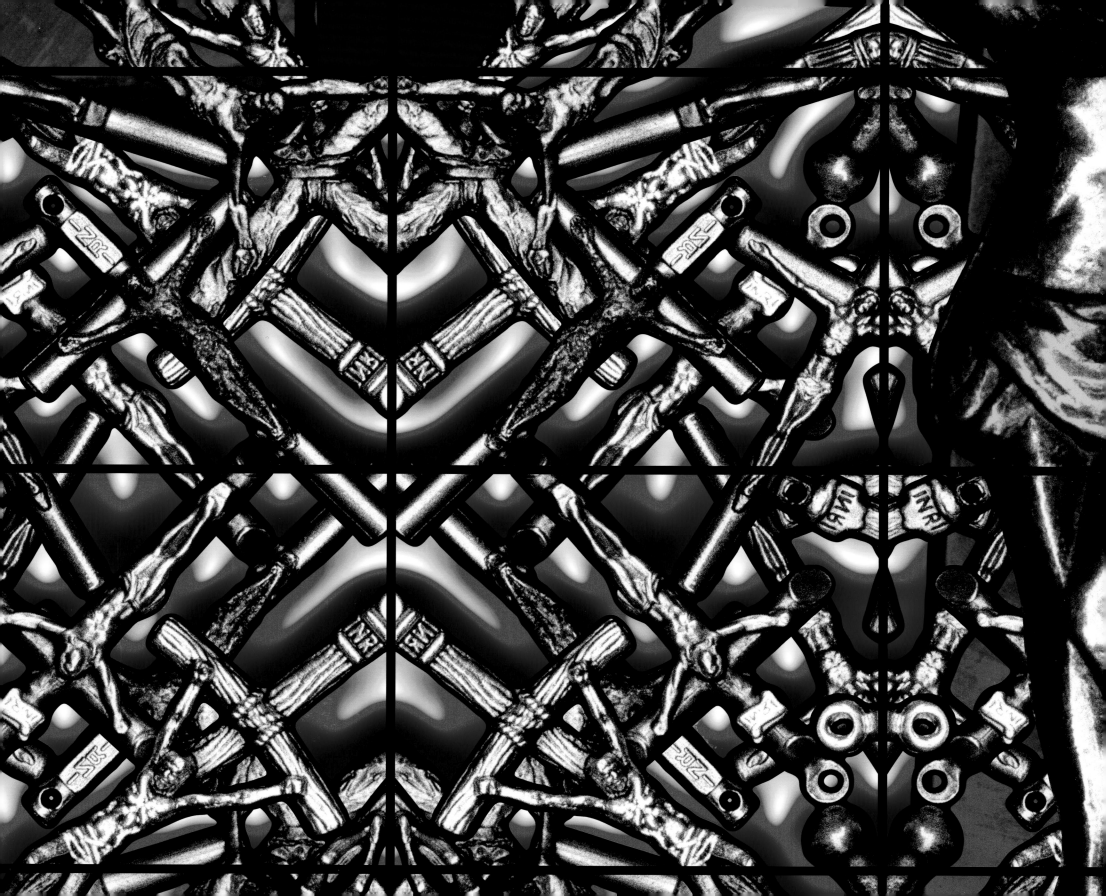

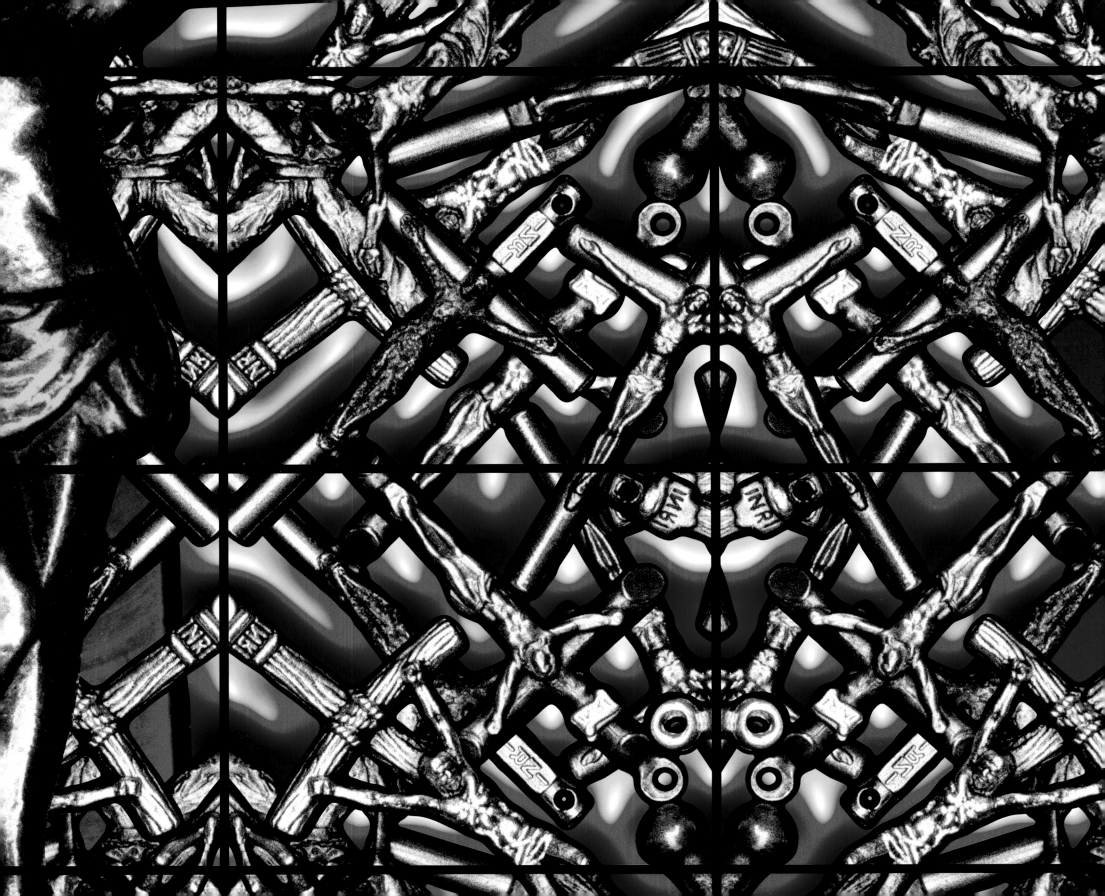

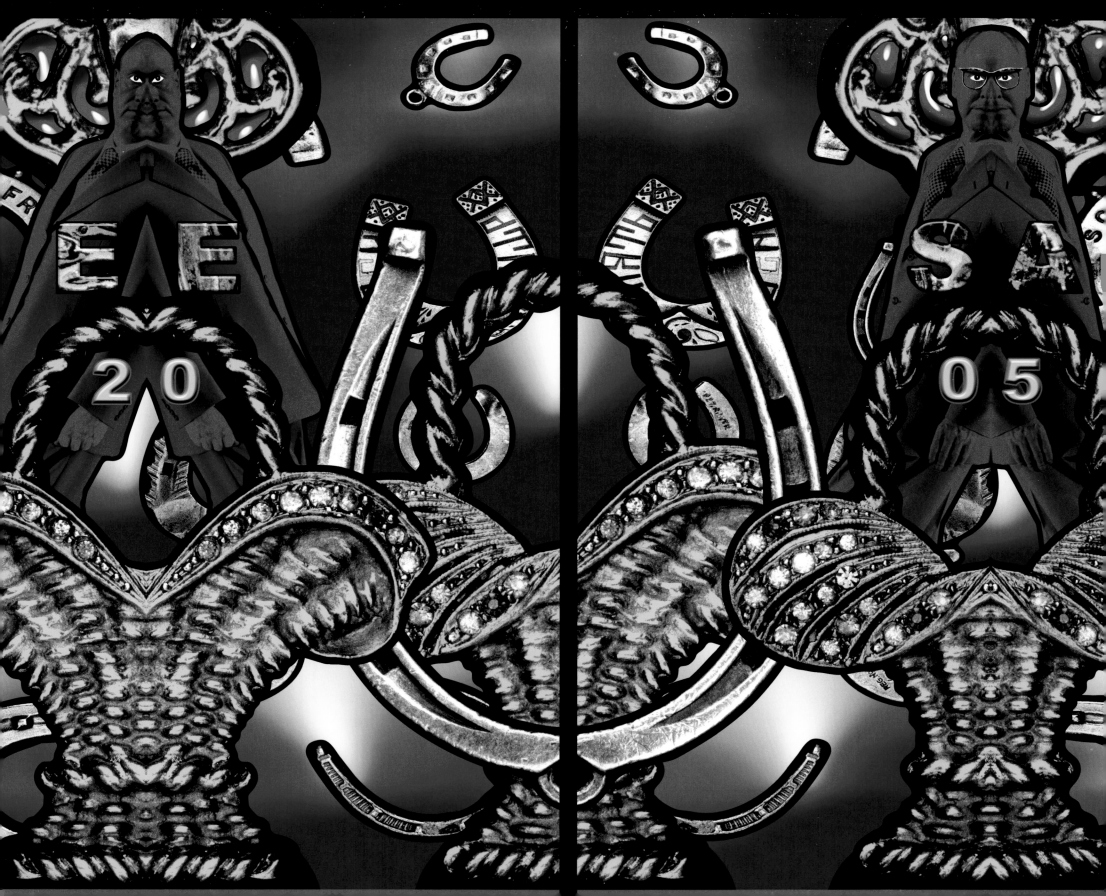

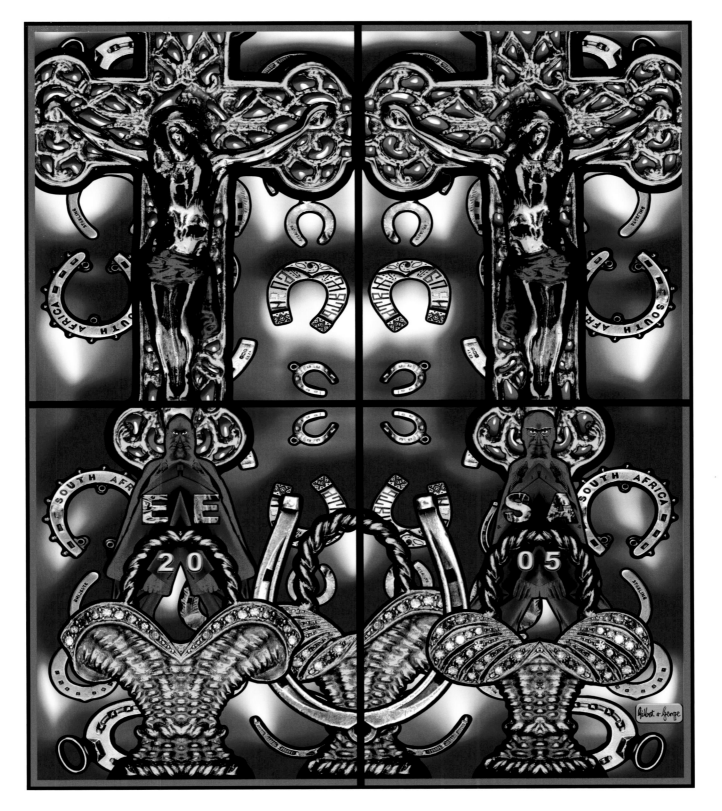

EESA 2005 151 X 127 cm

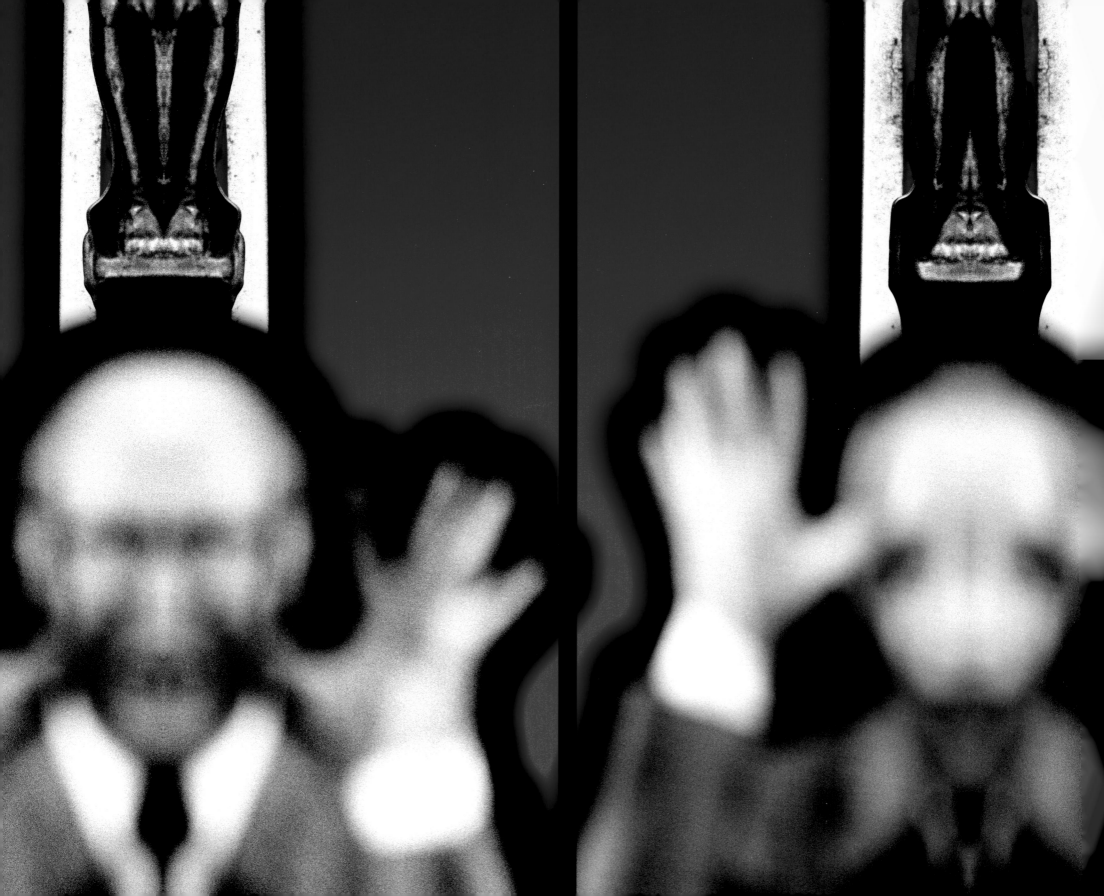

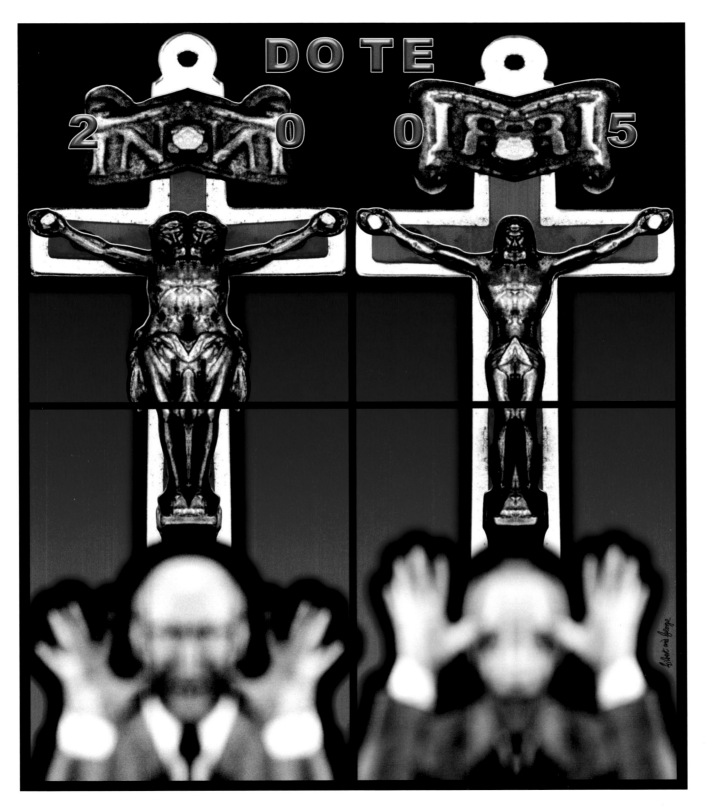

DOTE 2005 151 X 127 cm

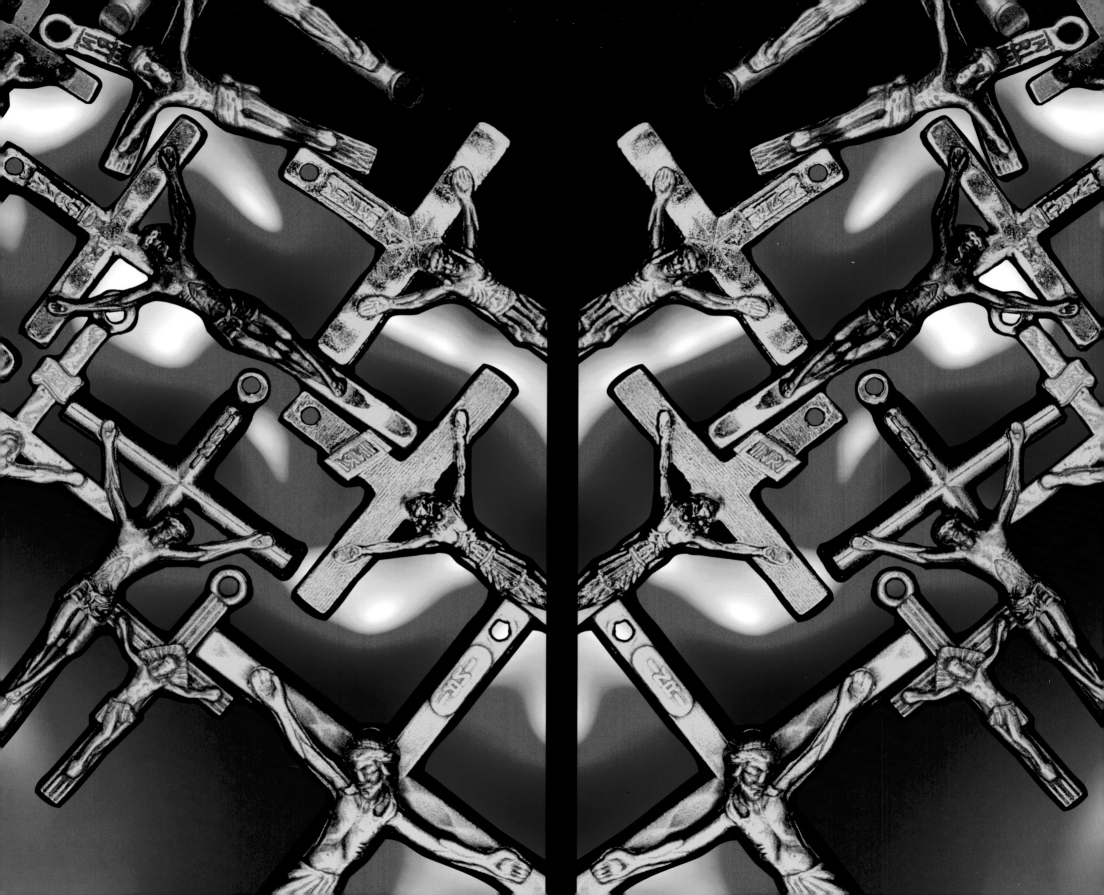

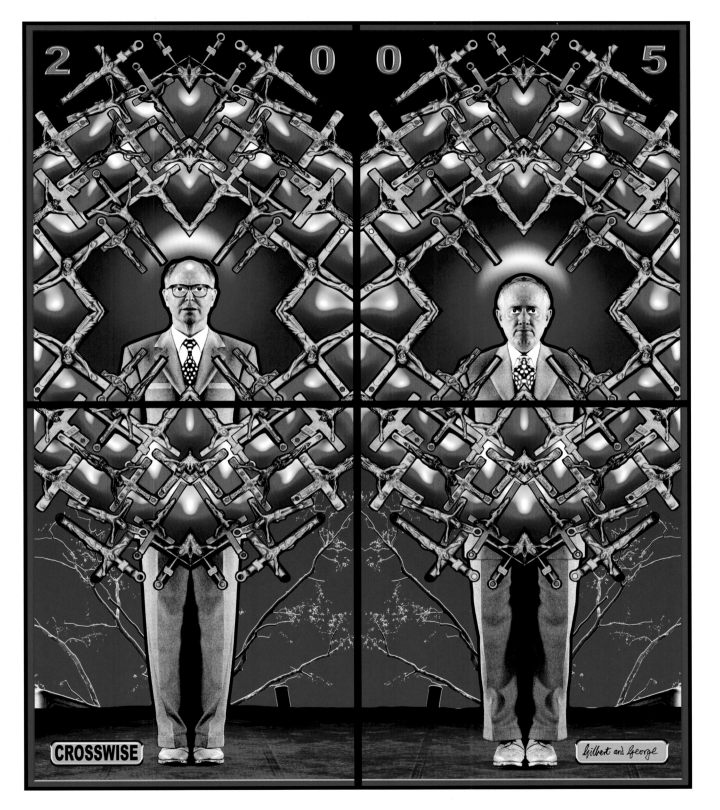

CROSSWISE 2005 151 X 127 cm

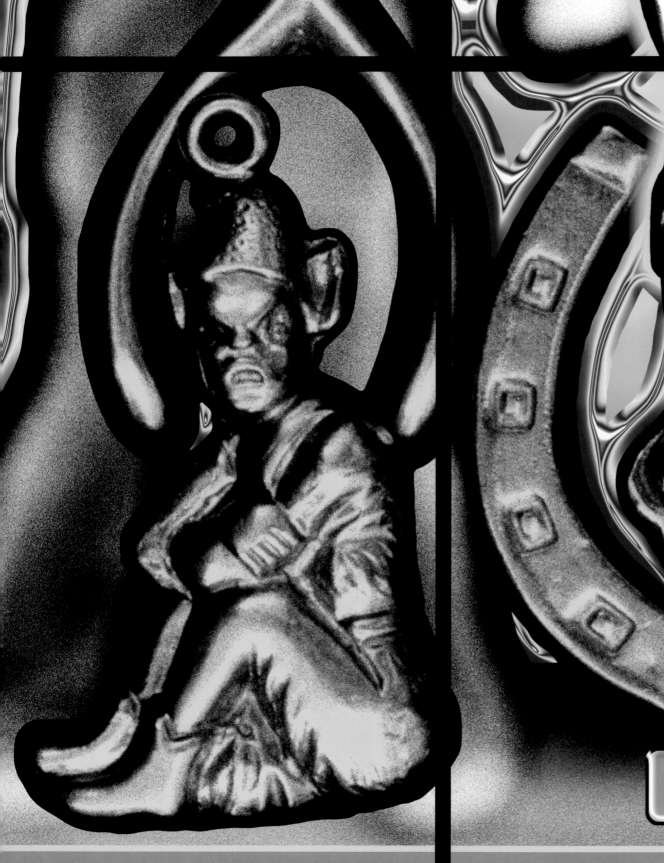

GOOD LUCK

hilbert and George

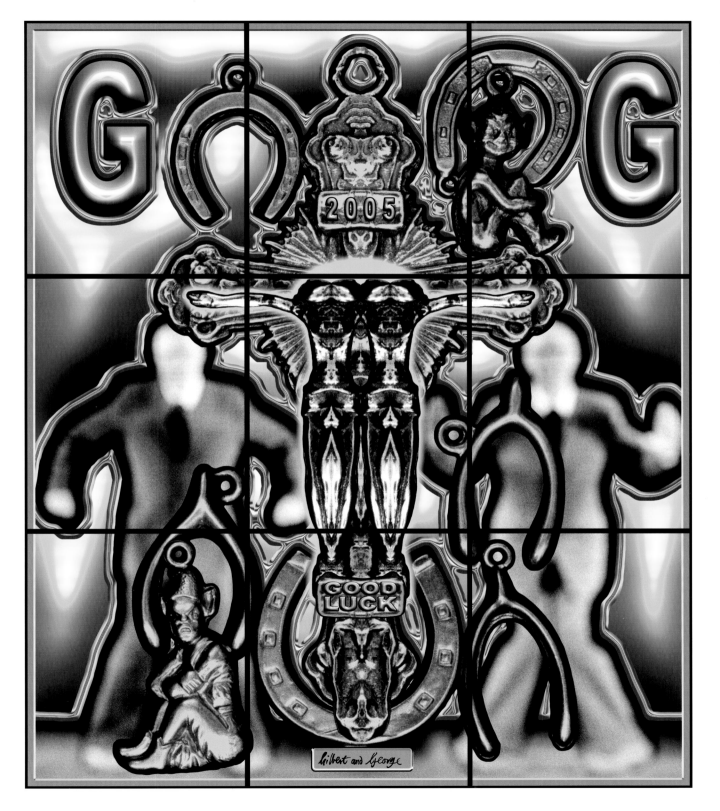

GOOD LUCK 2005 227 X 191 cm

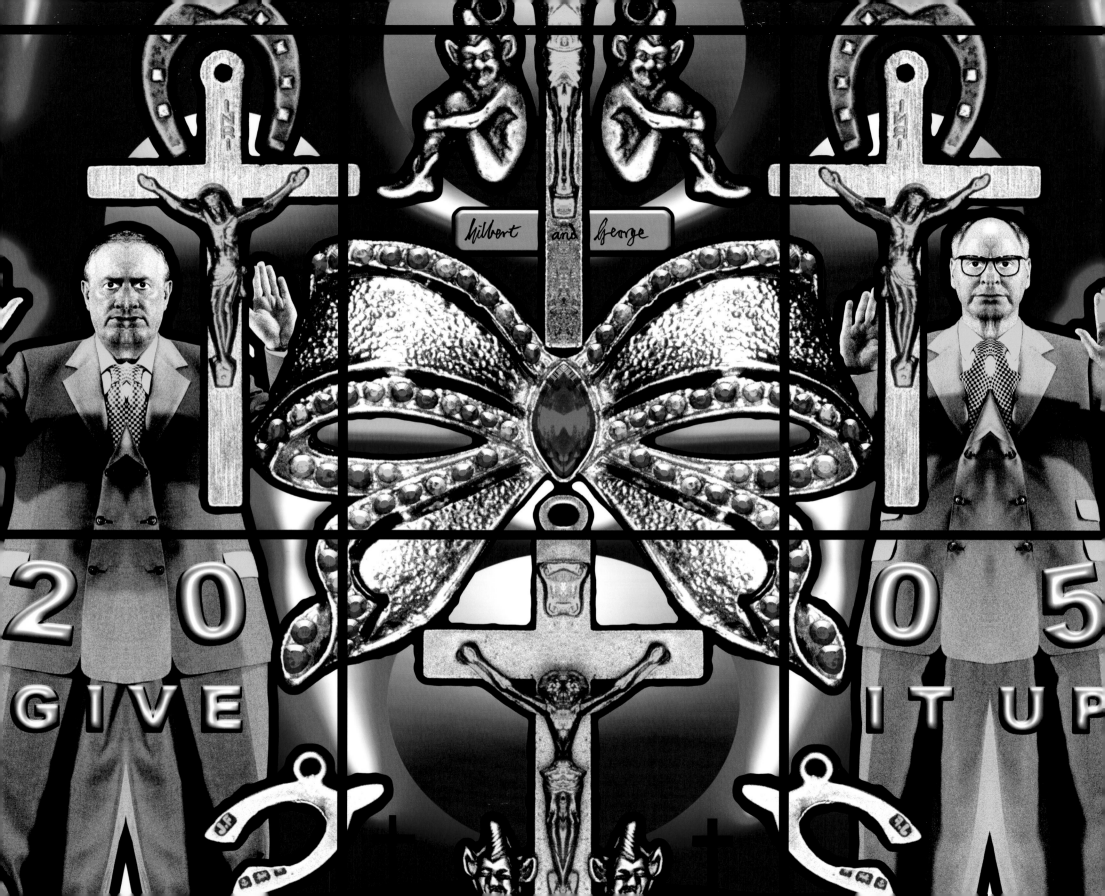

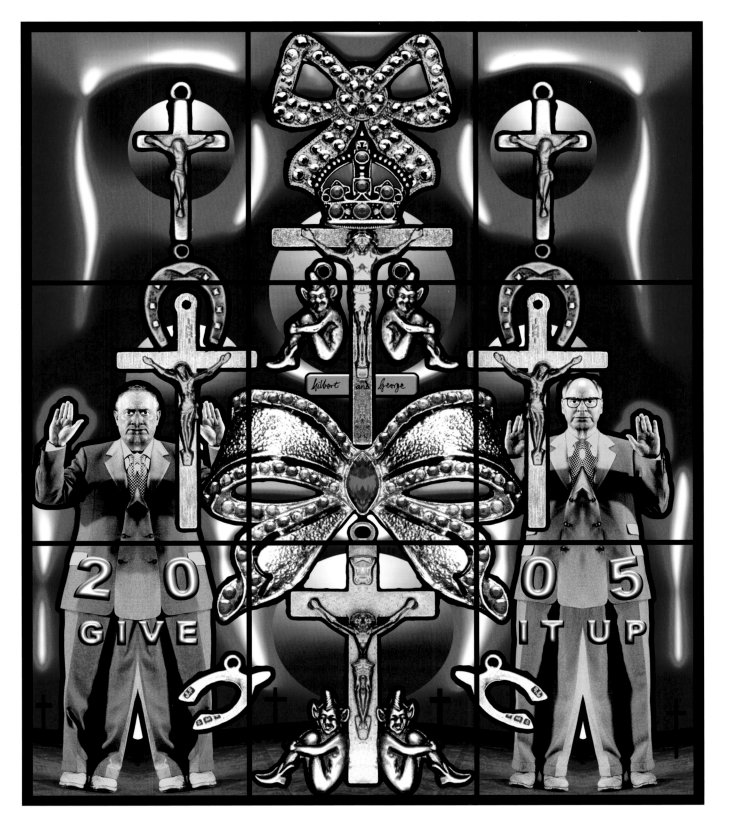

GIVE IT UP 2005 227 X 191 cm

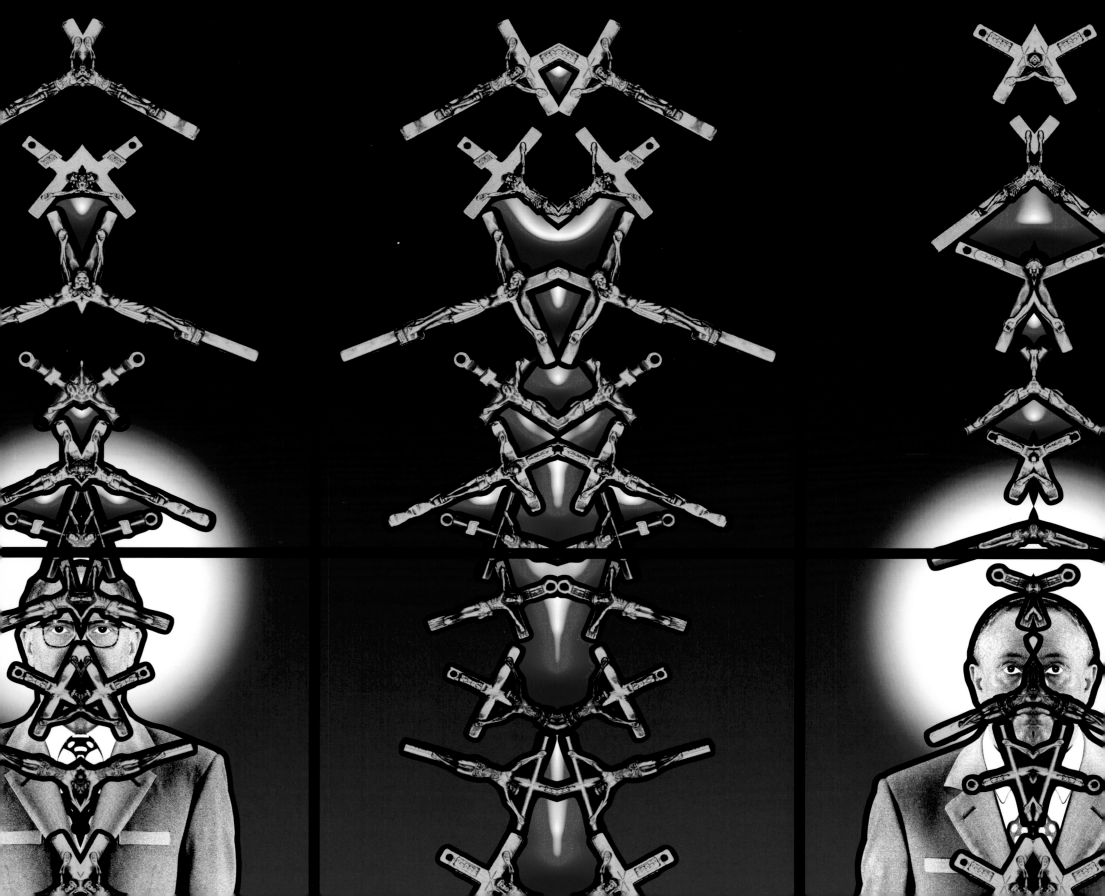

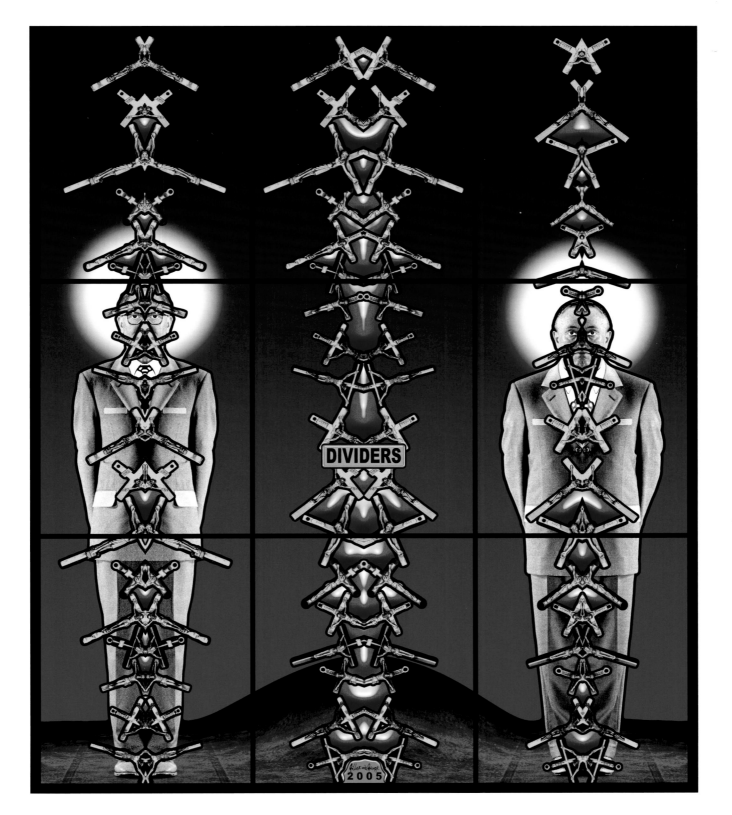

DIVIDERS 2005 227 X 191 cm

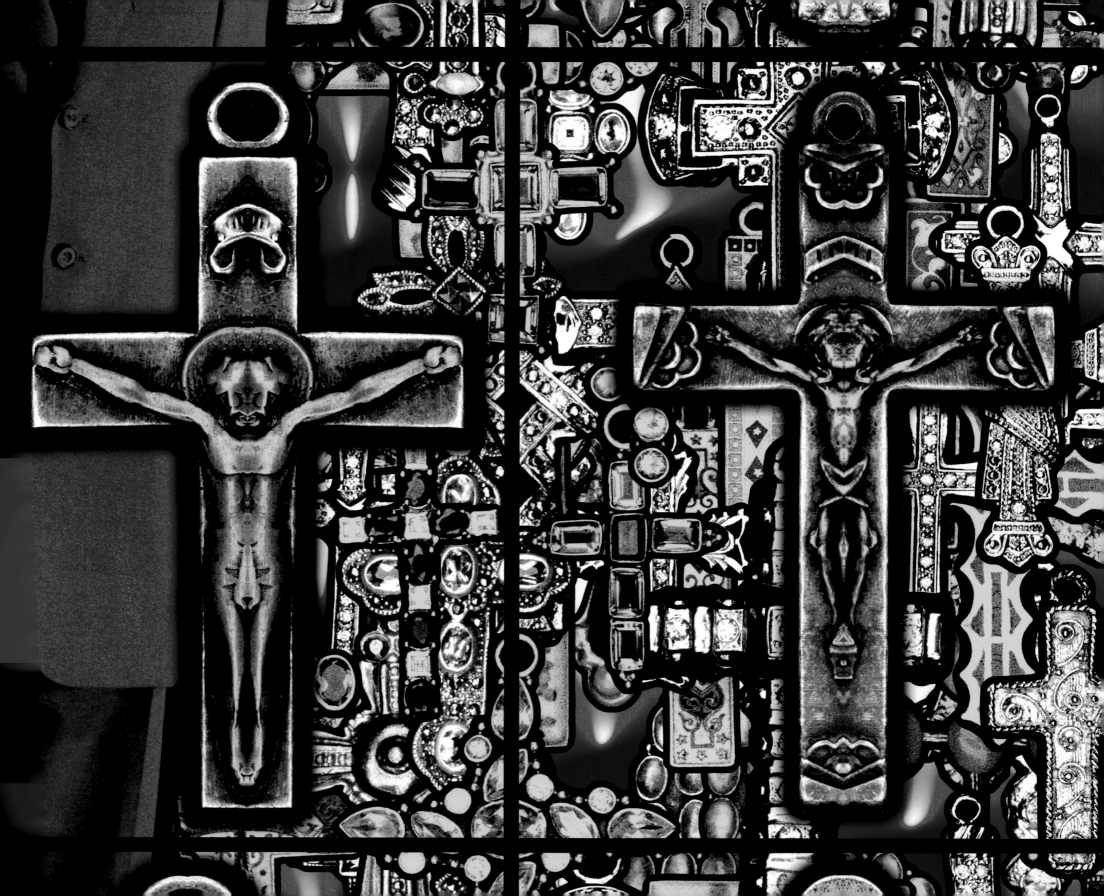

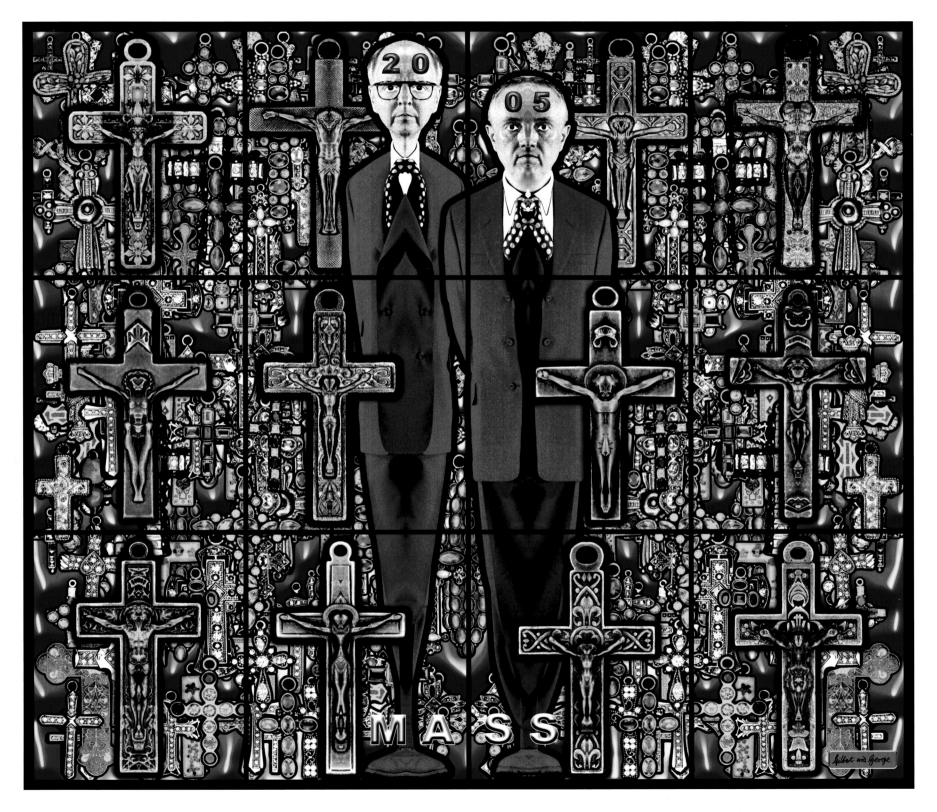

MASS 2005 227 X 254 cm

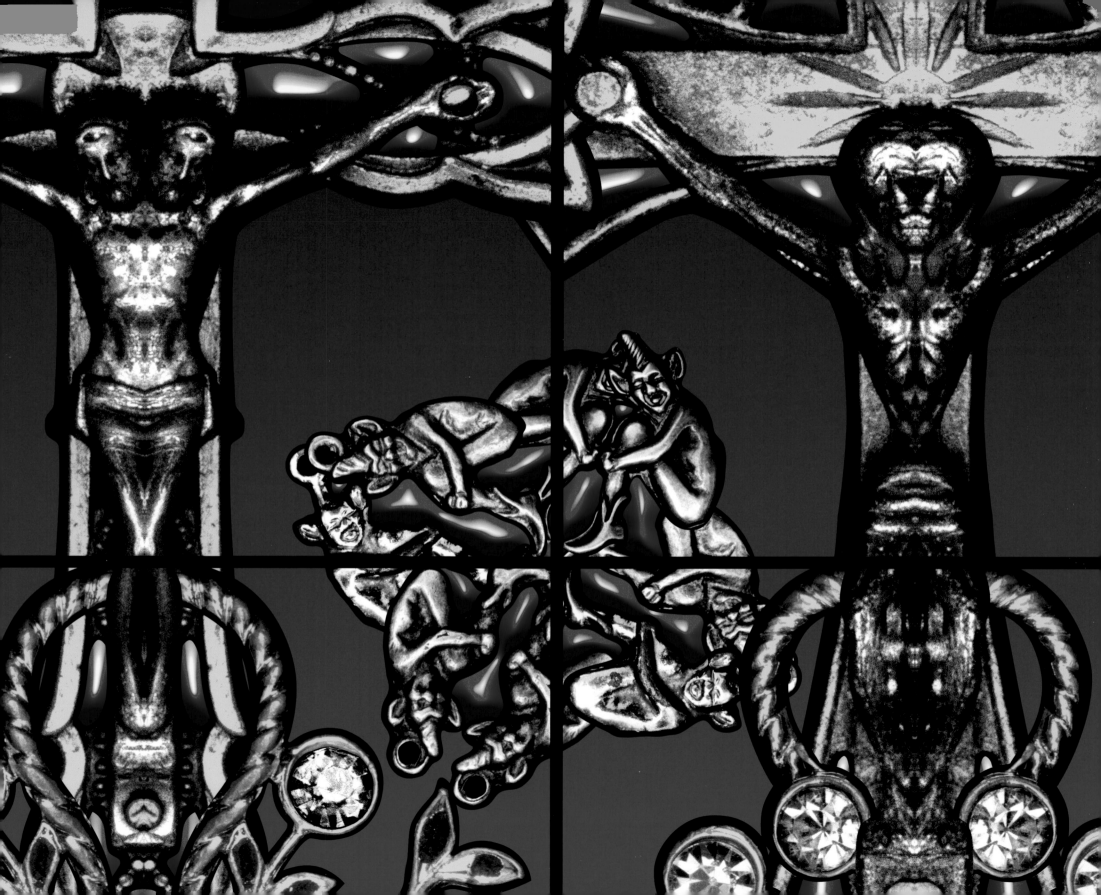

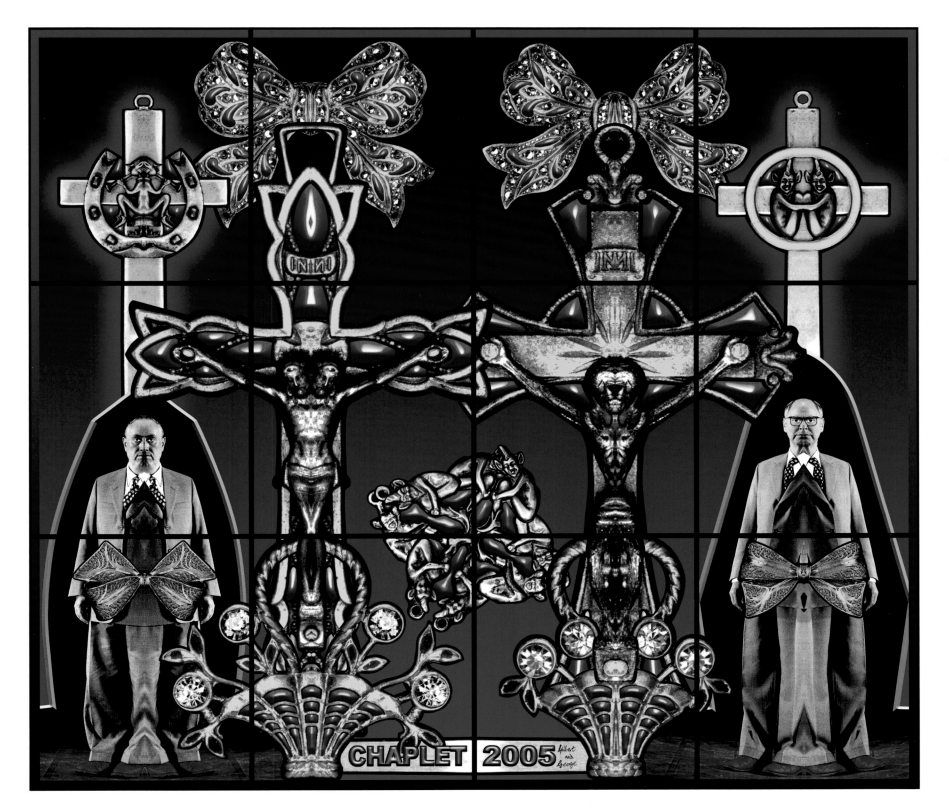

CHAPLET 2005 227 X 254 cm

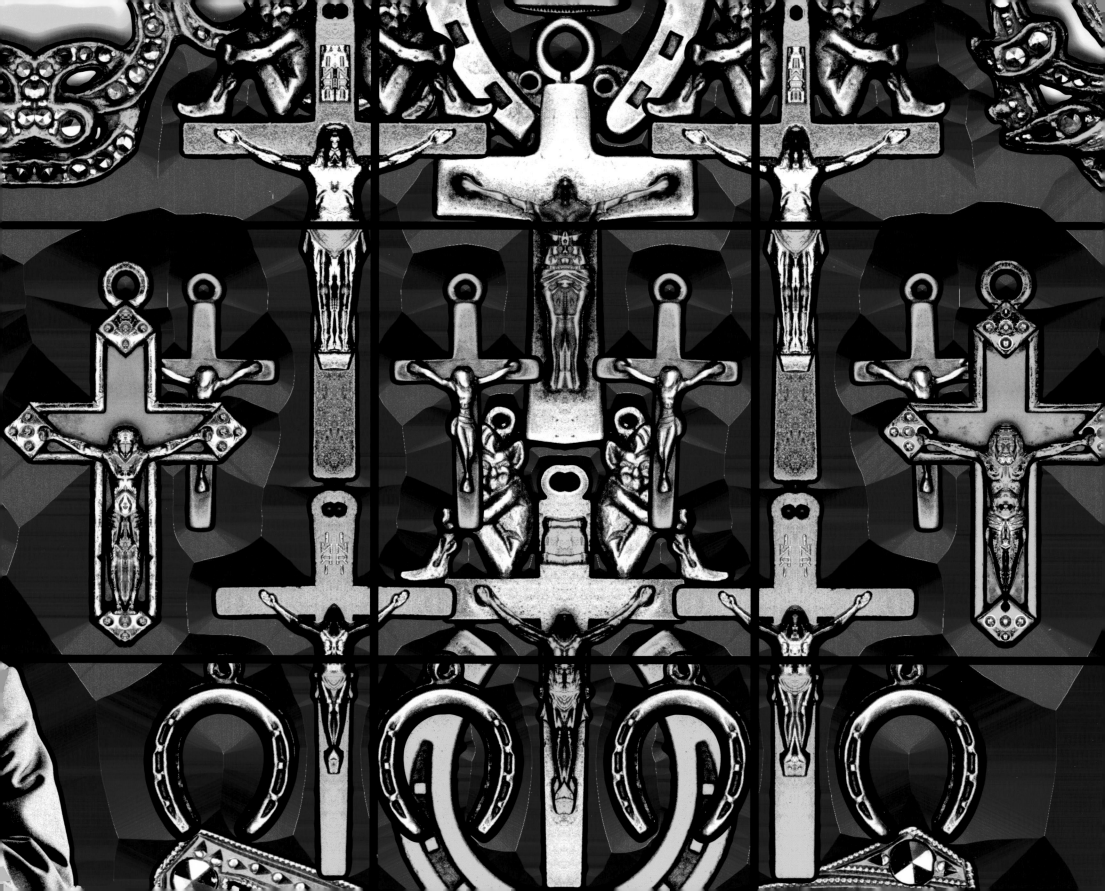

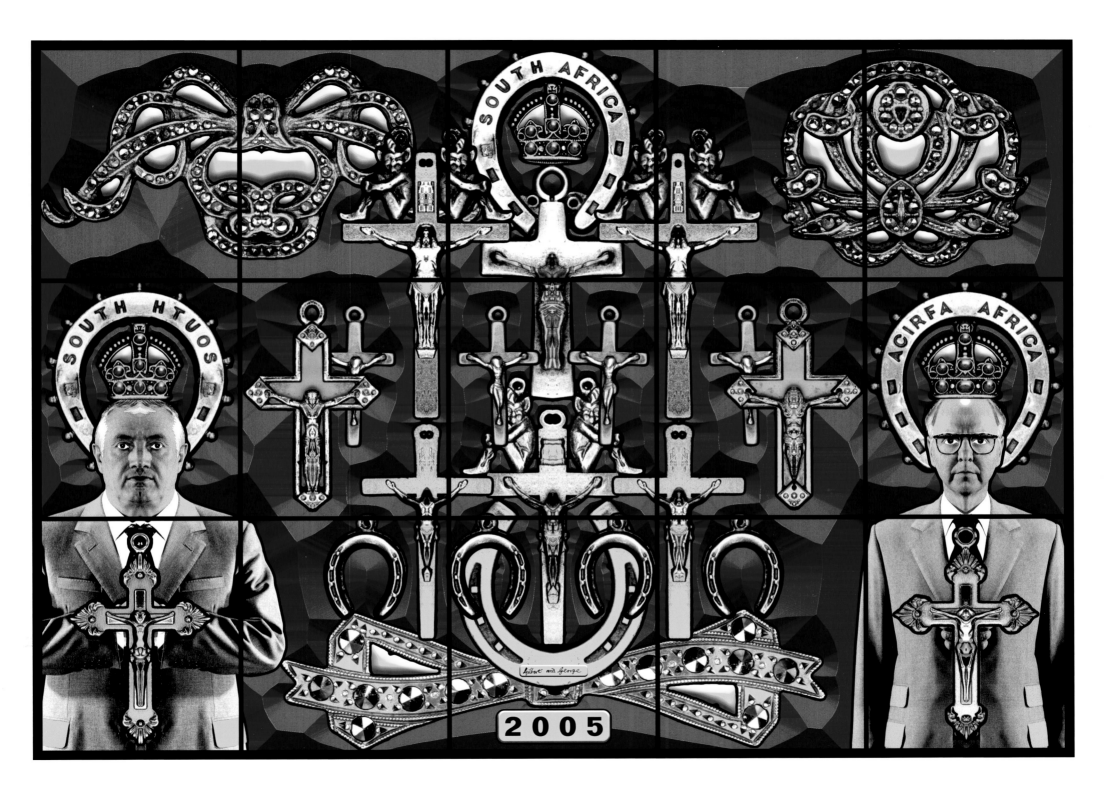

SOUTH AFRICA 2005 227 X 318 cm

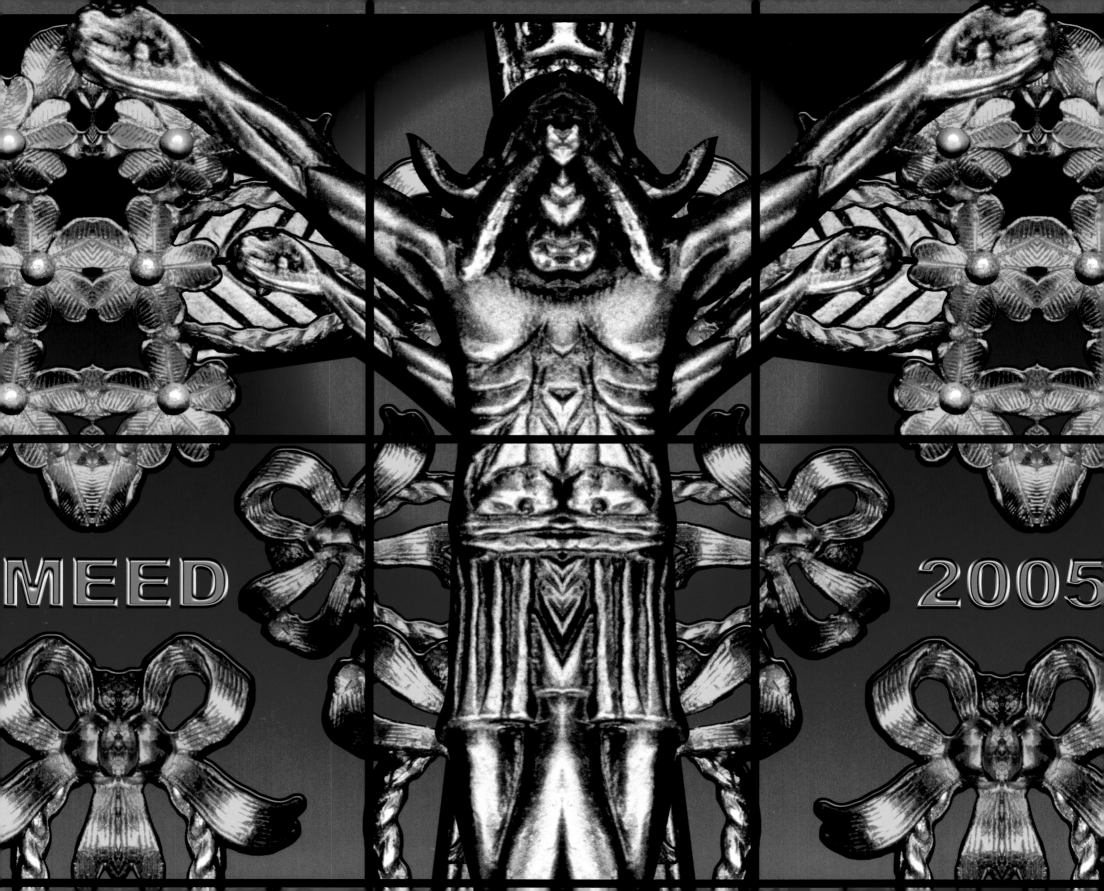

MEED 2005

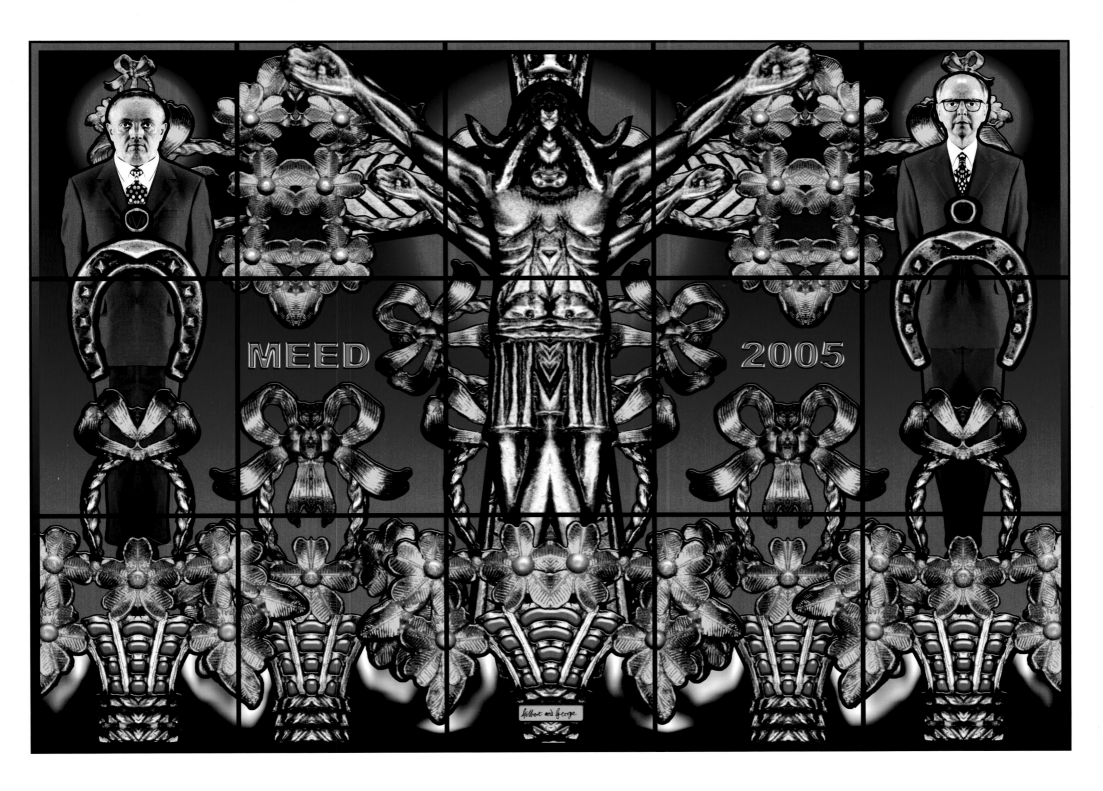

MEED 2005 227 X 318 cm

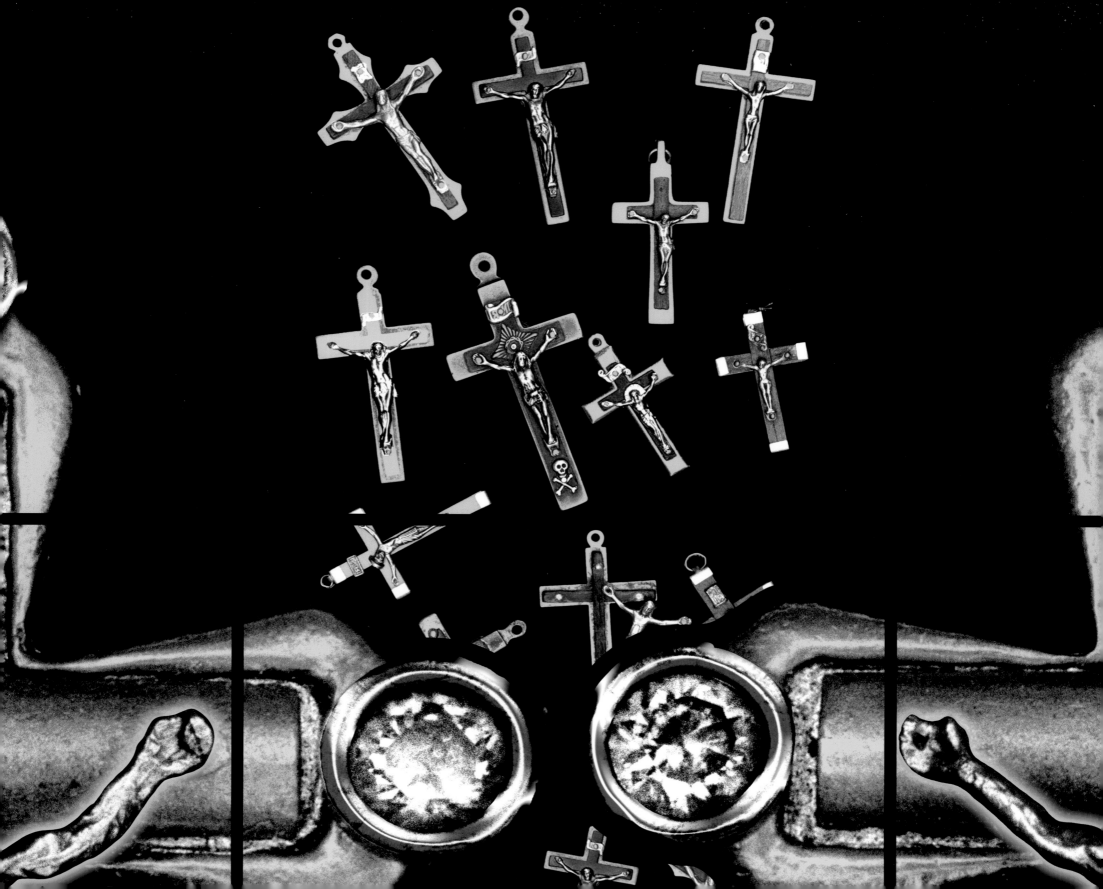

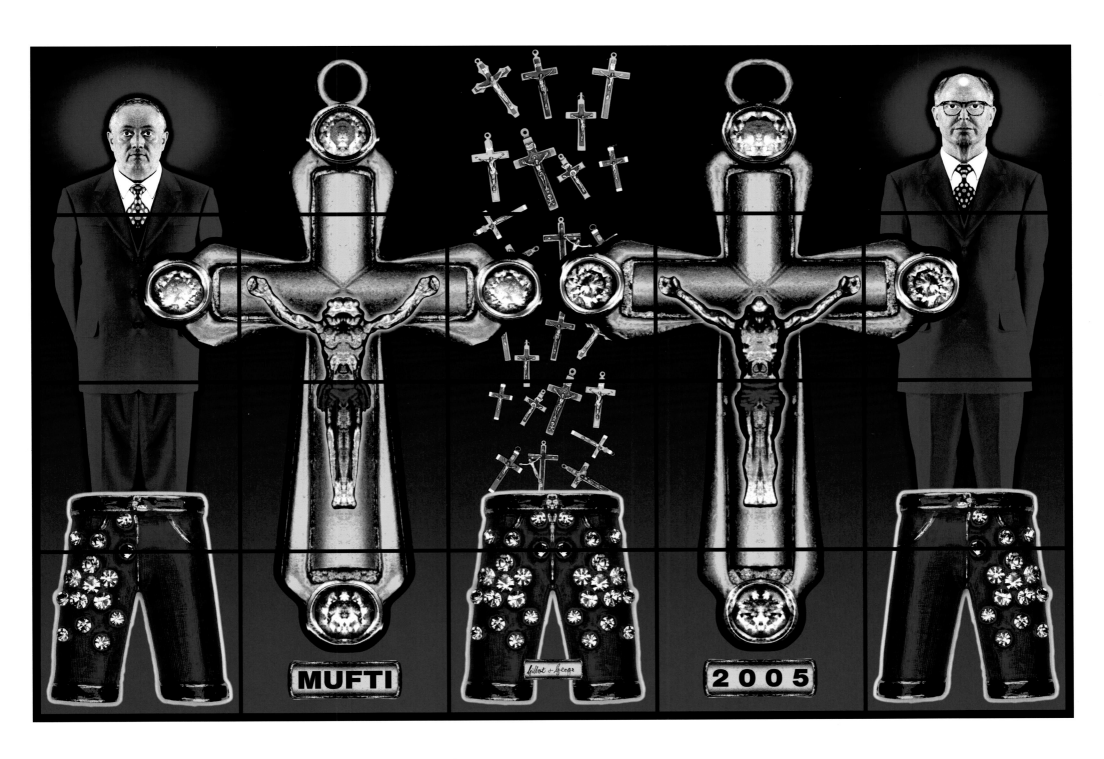

MUFTI 2005 254 X 378 cm

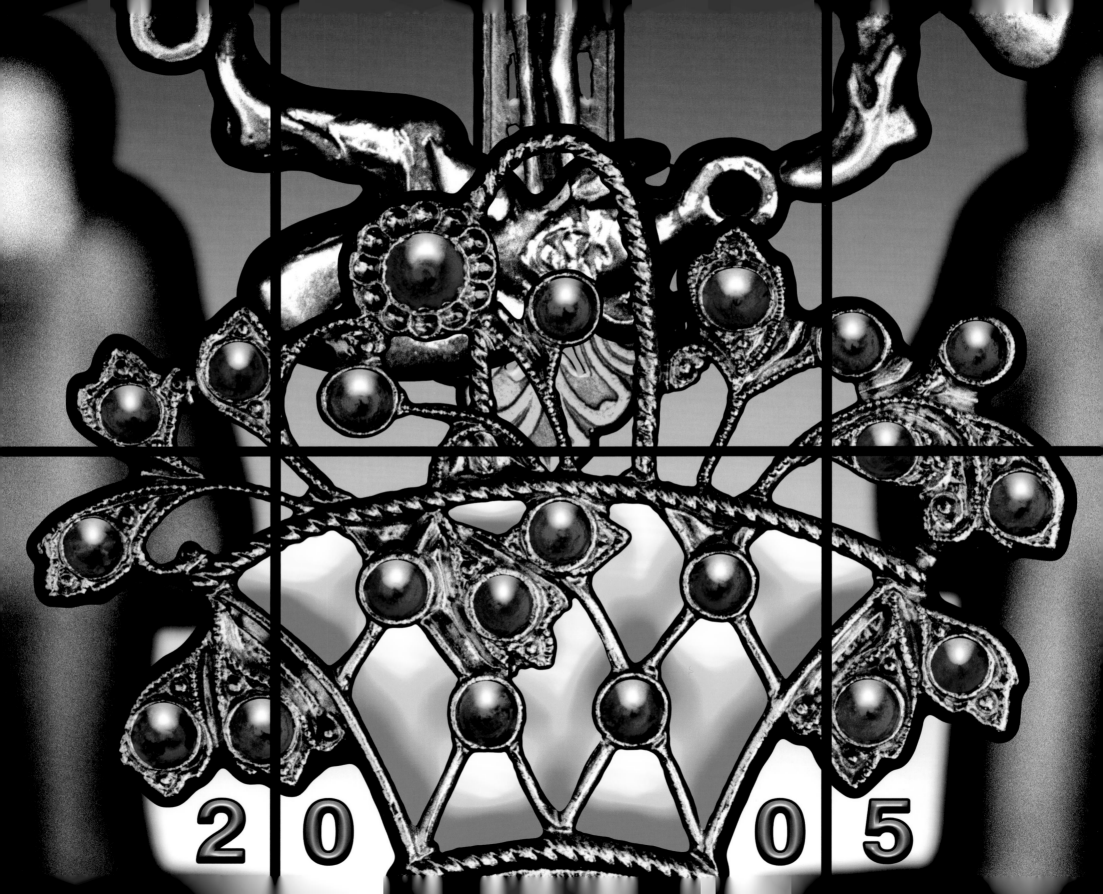

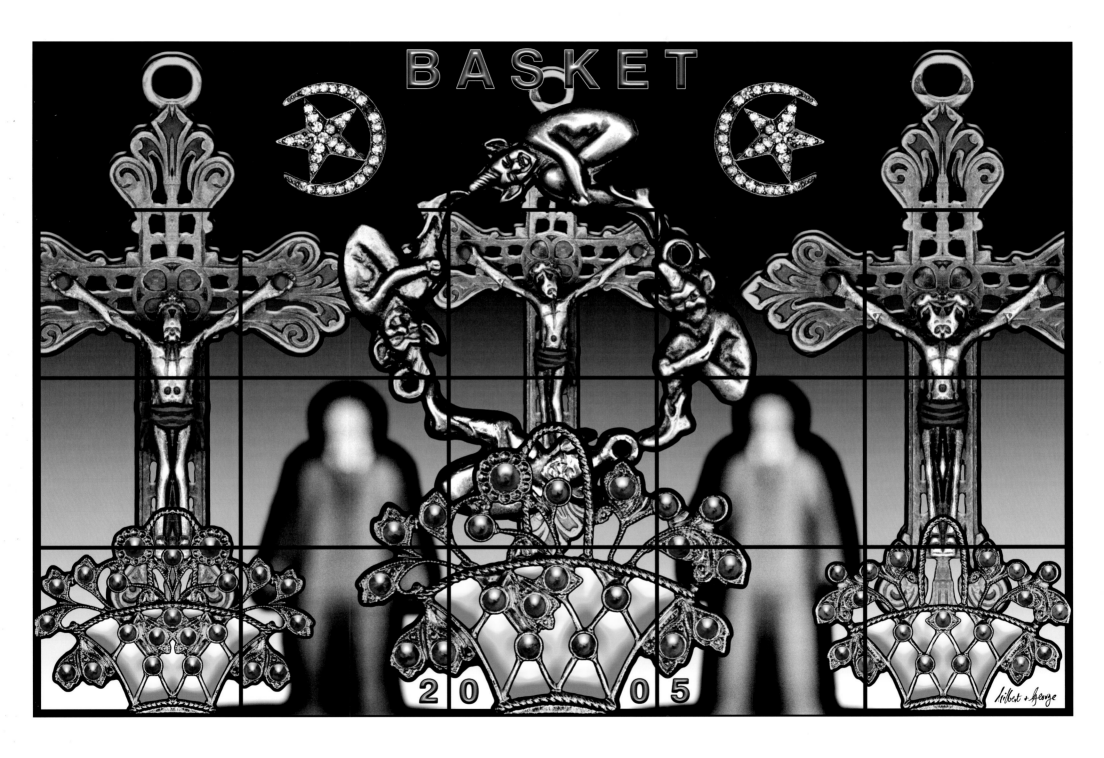

BASKET 2005 254 X 378 cm

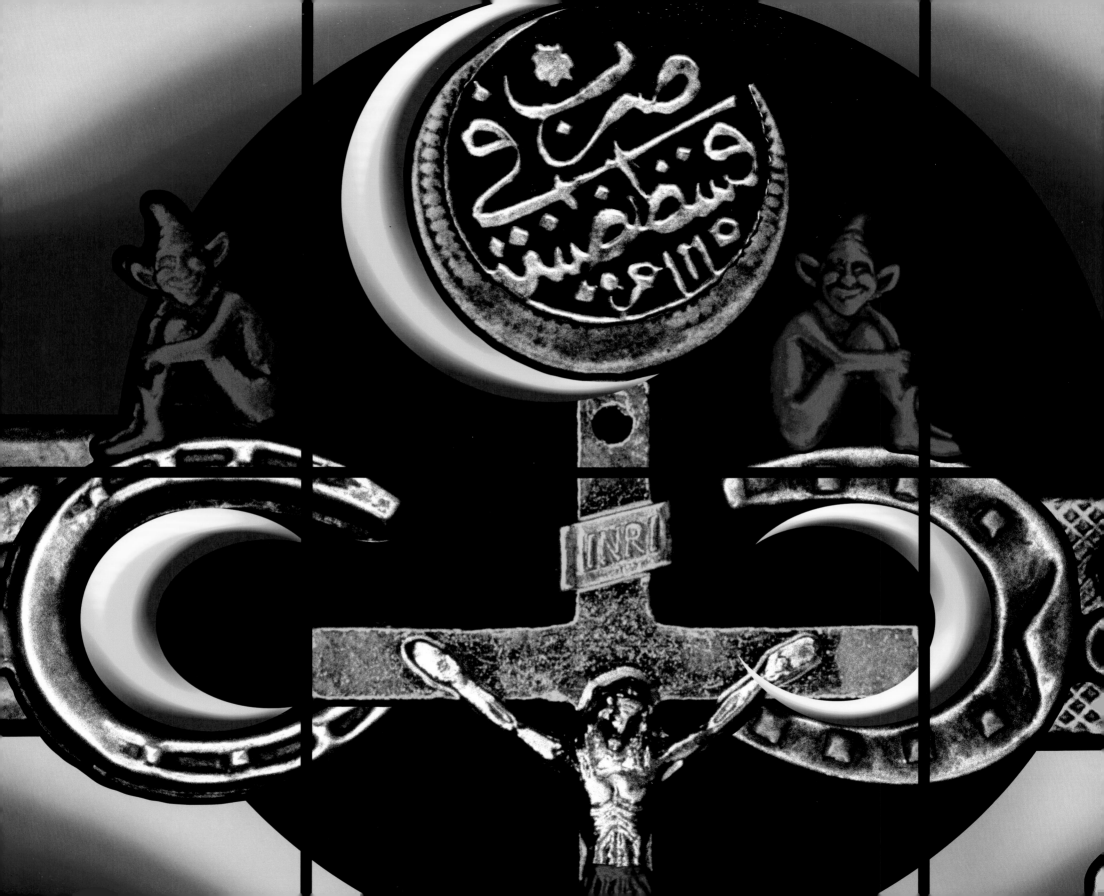

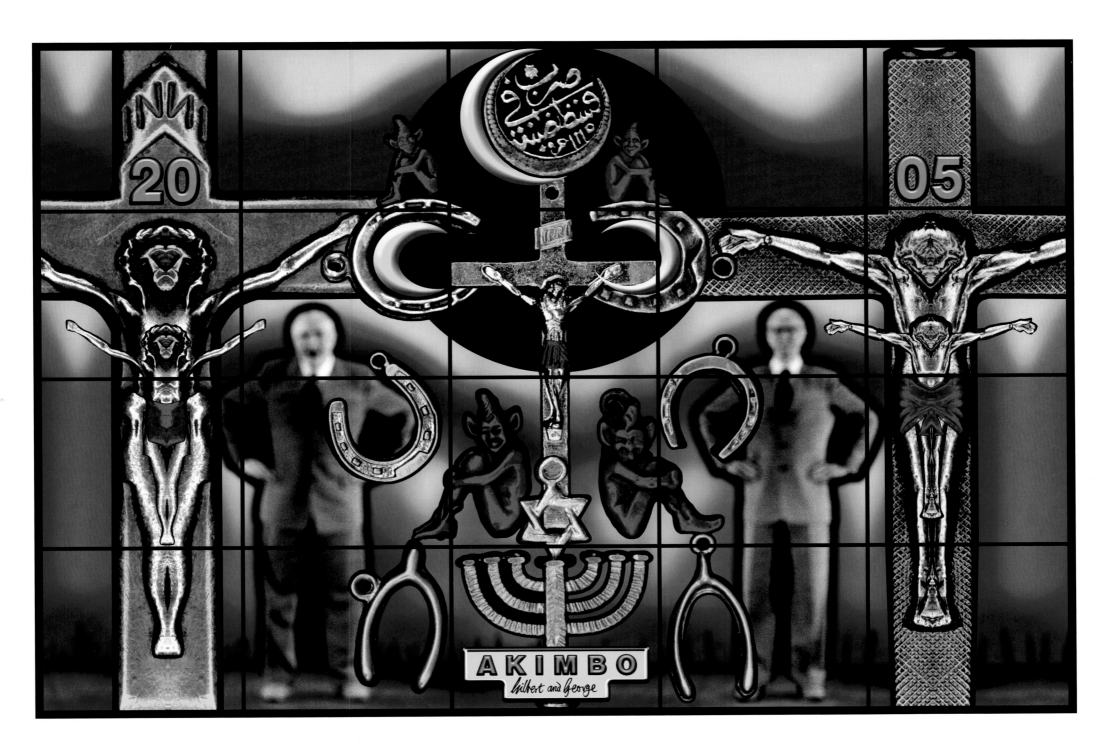

AKIMBO 2005 254 X 378 cm

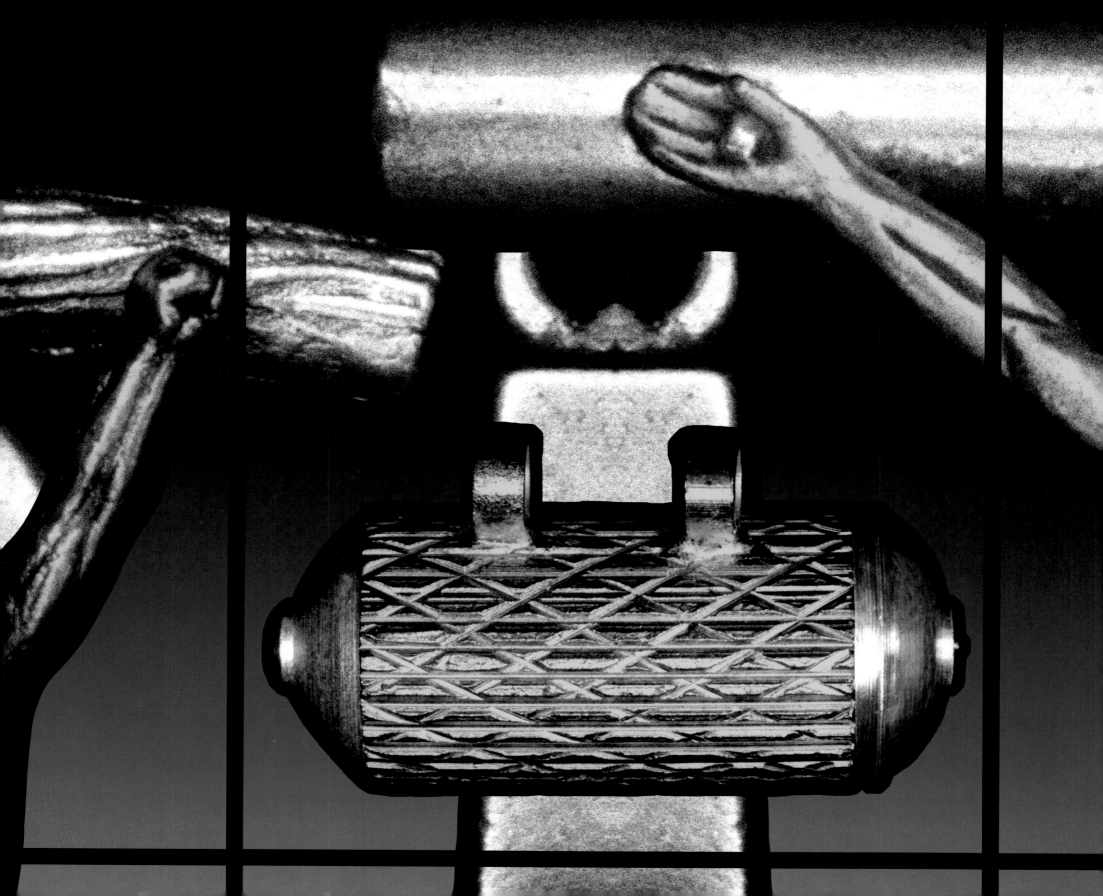

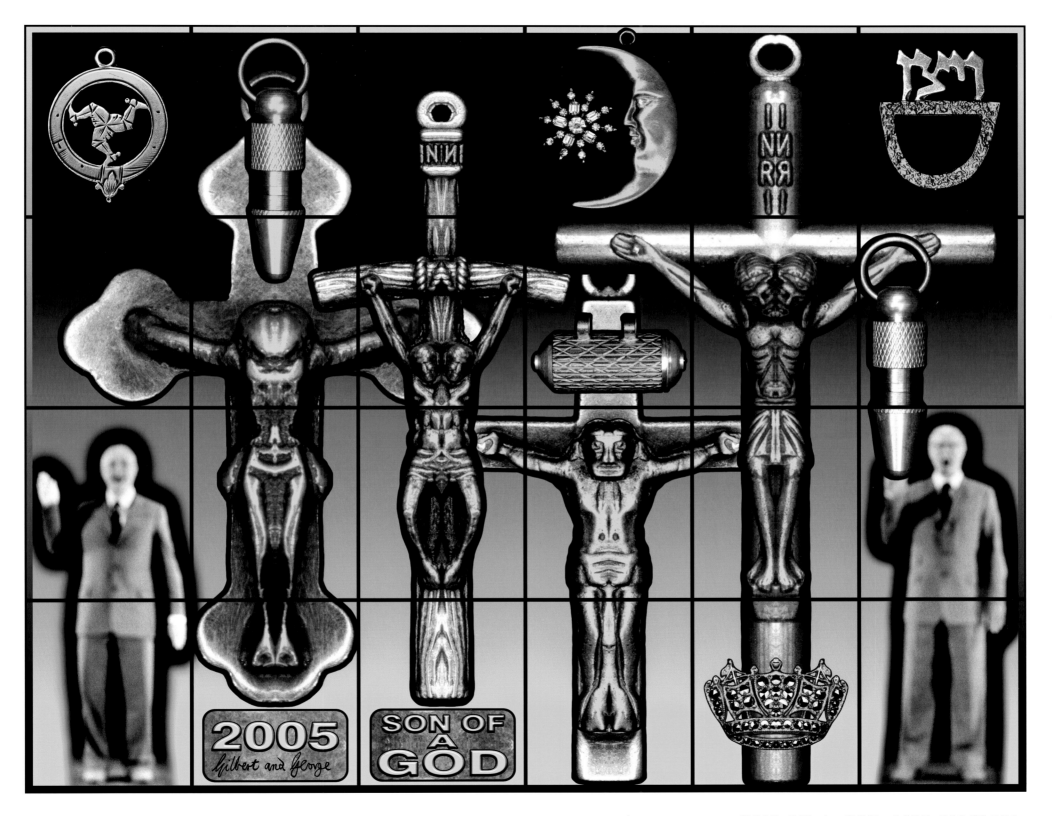

SON OF A GOD 2005 302 X 381 cm

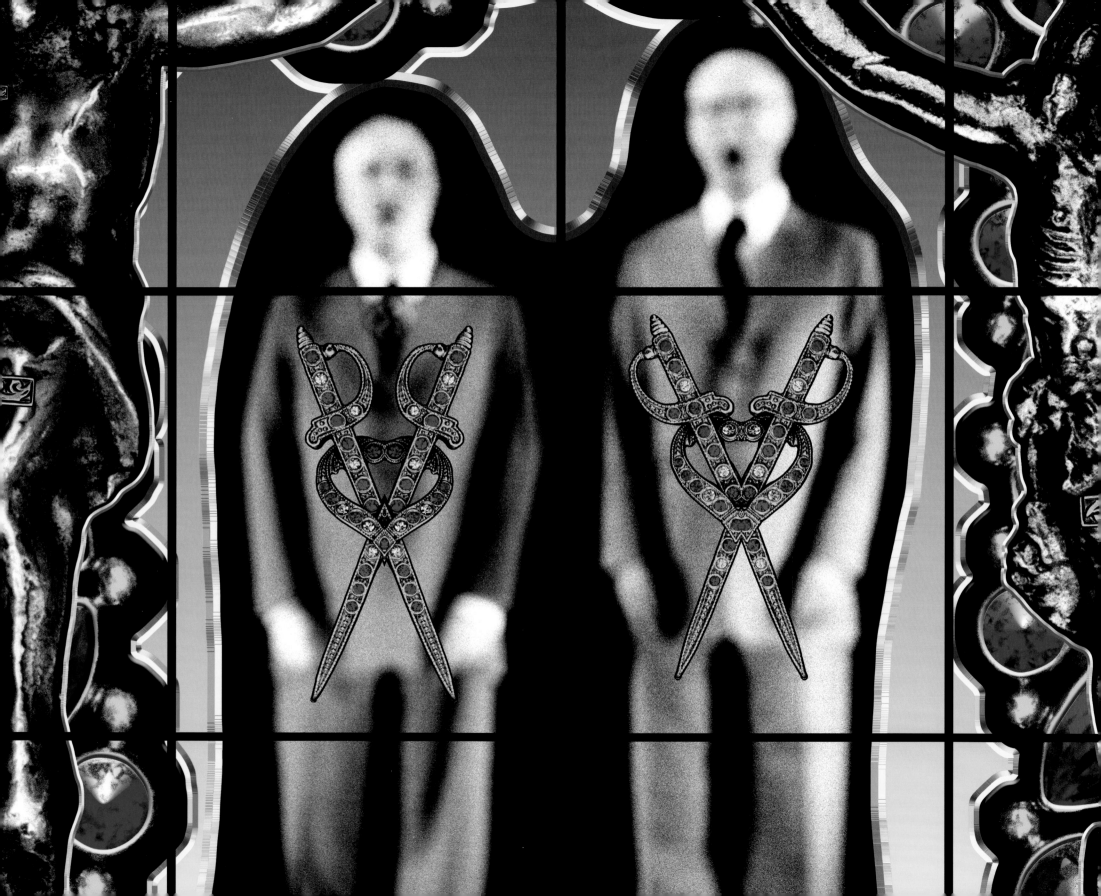

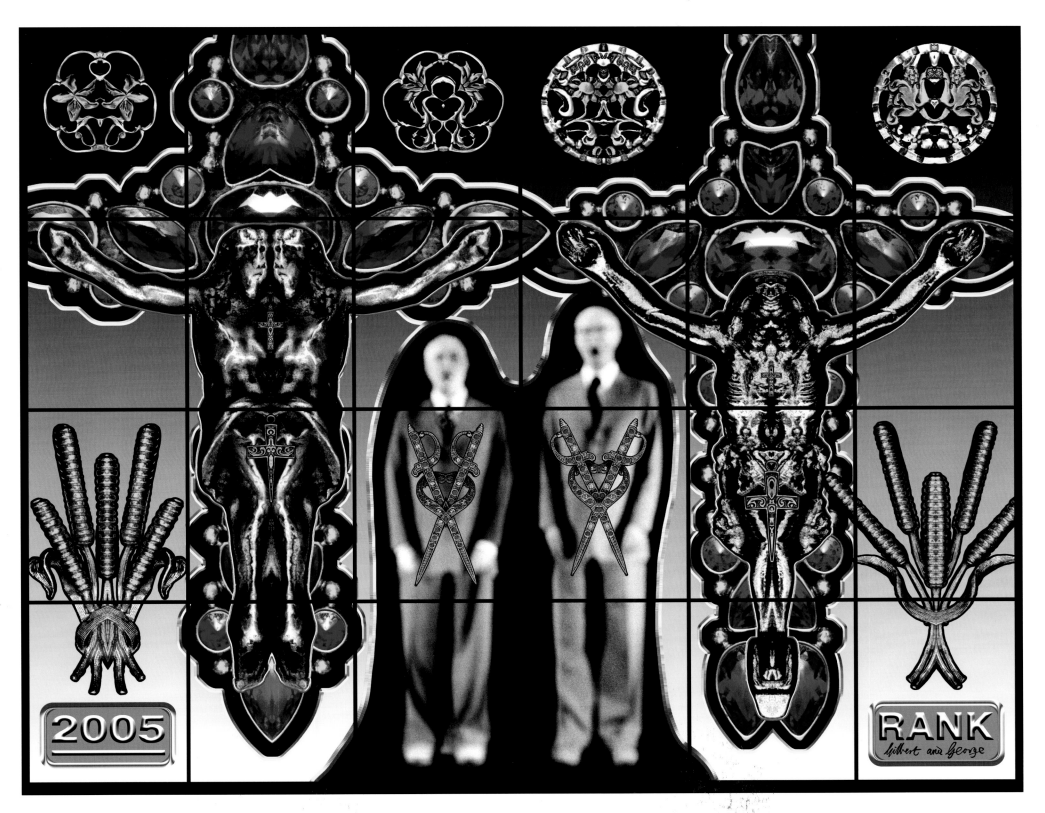

2005

RANK
Gilbert and George

RANK 2005 302 X 381 cm

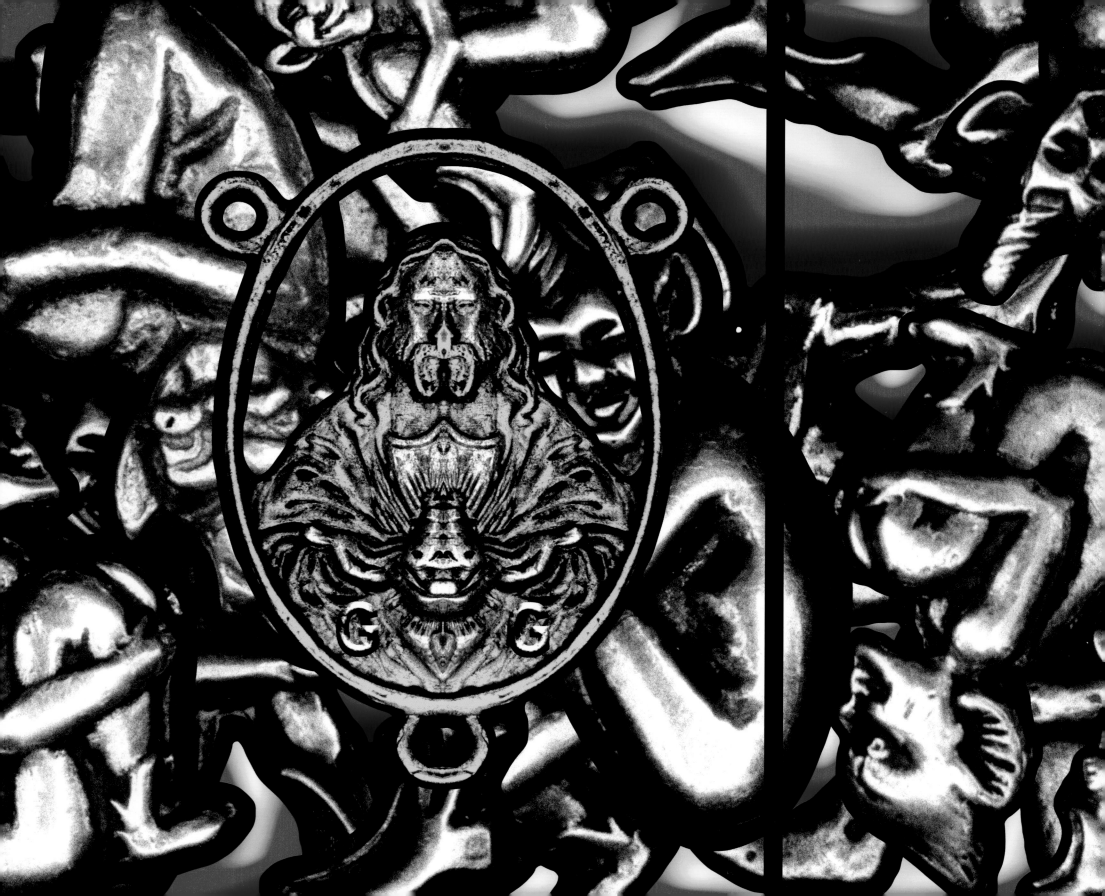

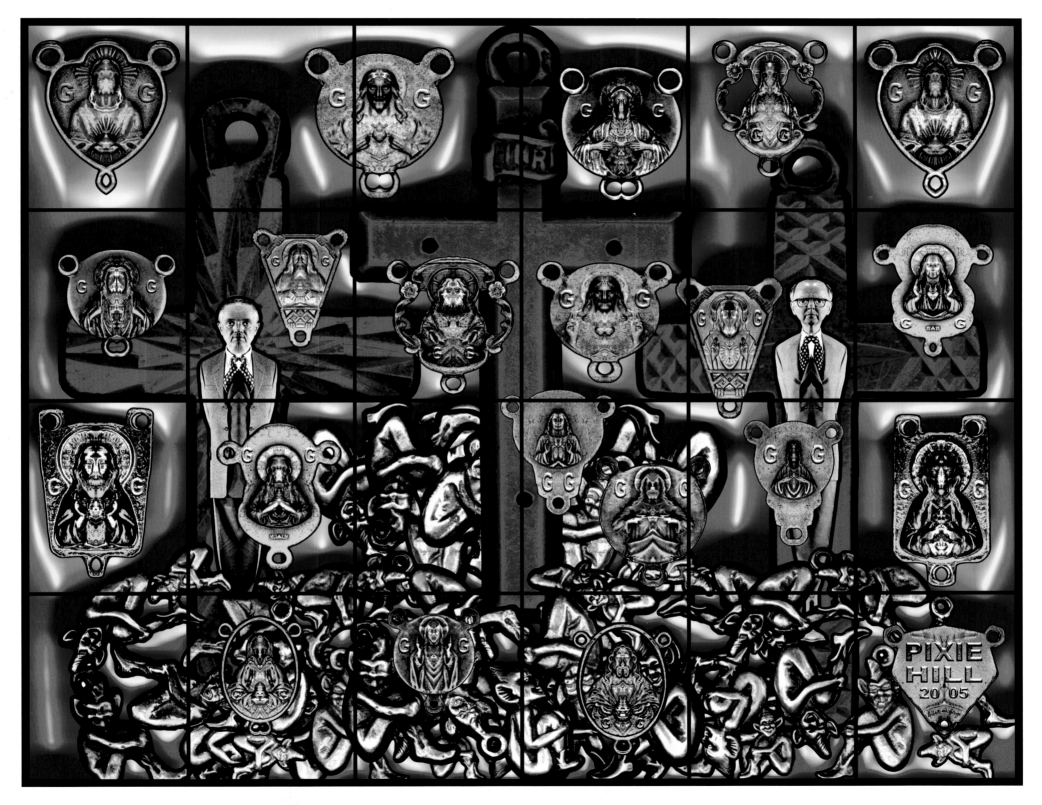

PIXIE HILL 2005 302 X 381 cm

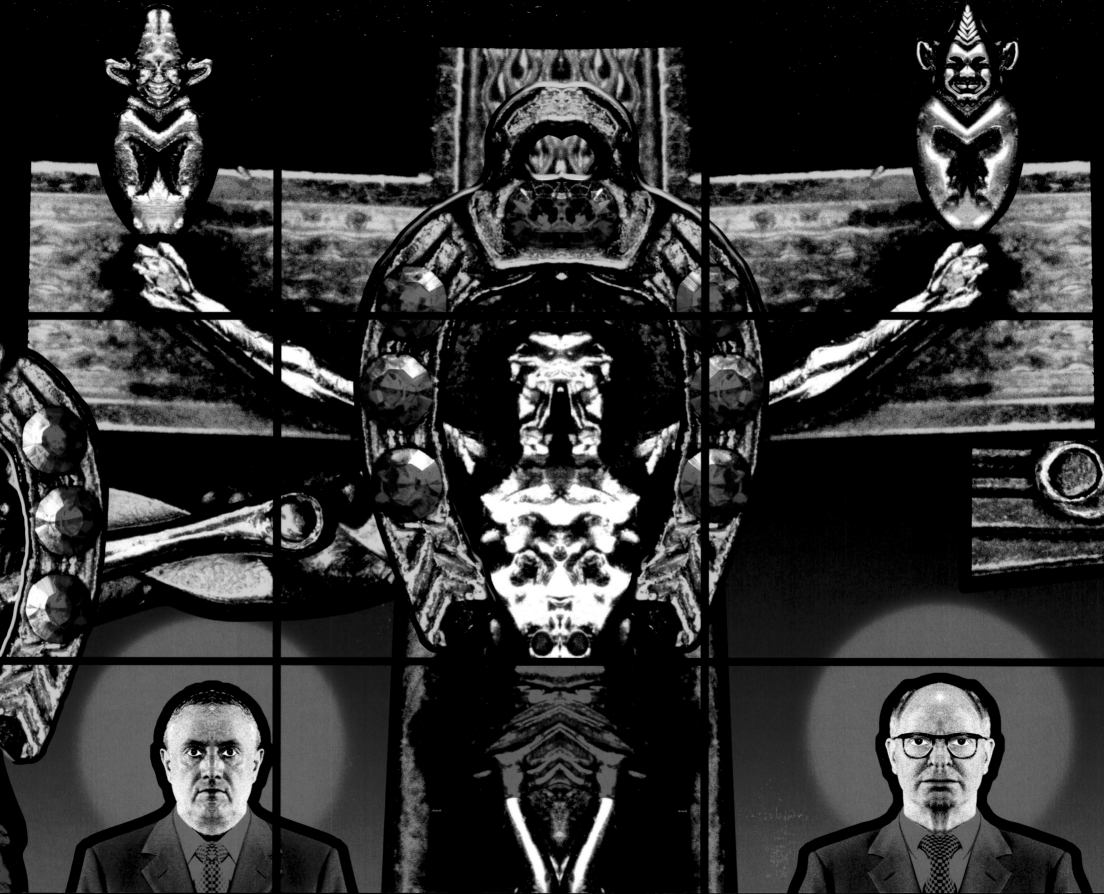

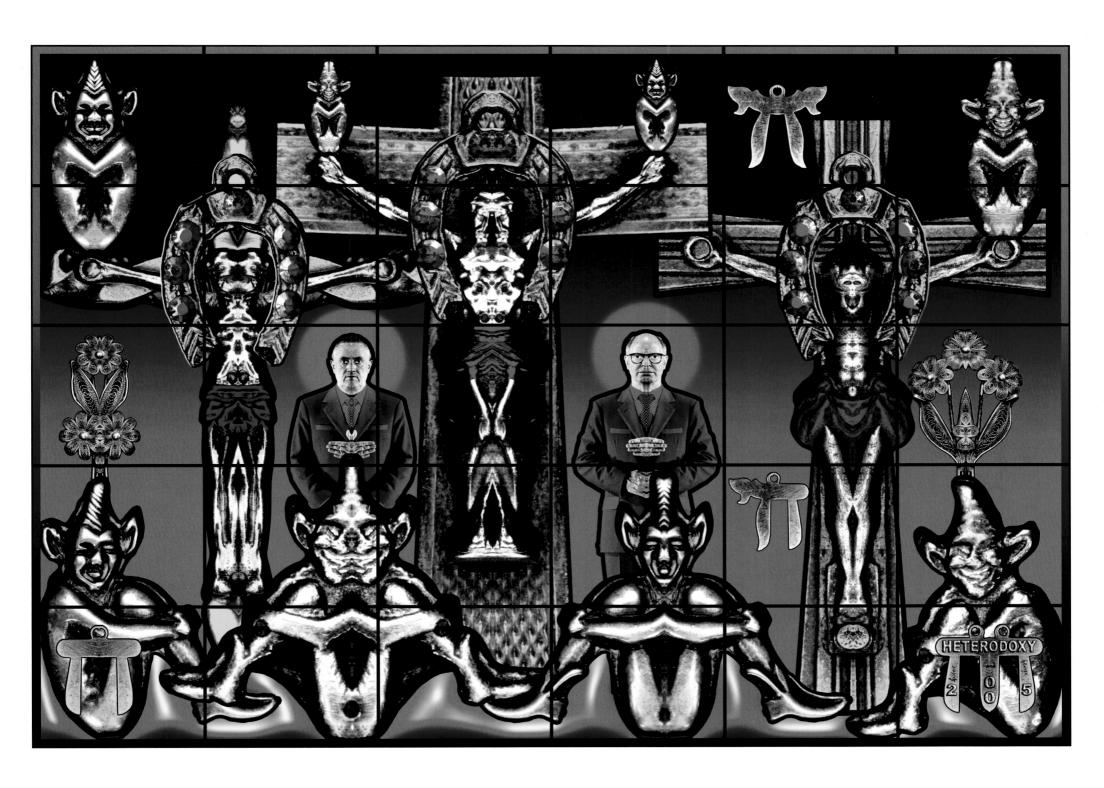

HETERODOXY 2005 318 X 453 cm

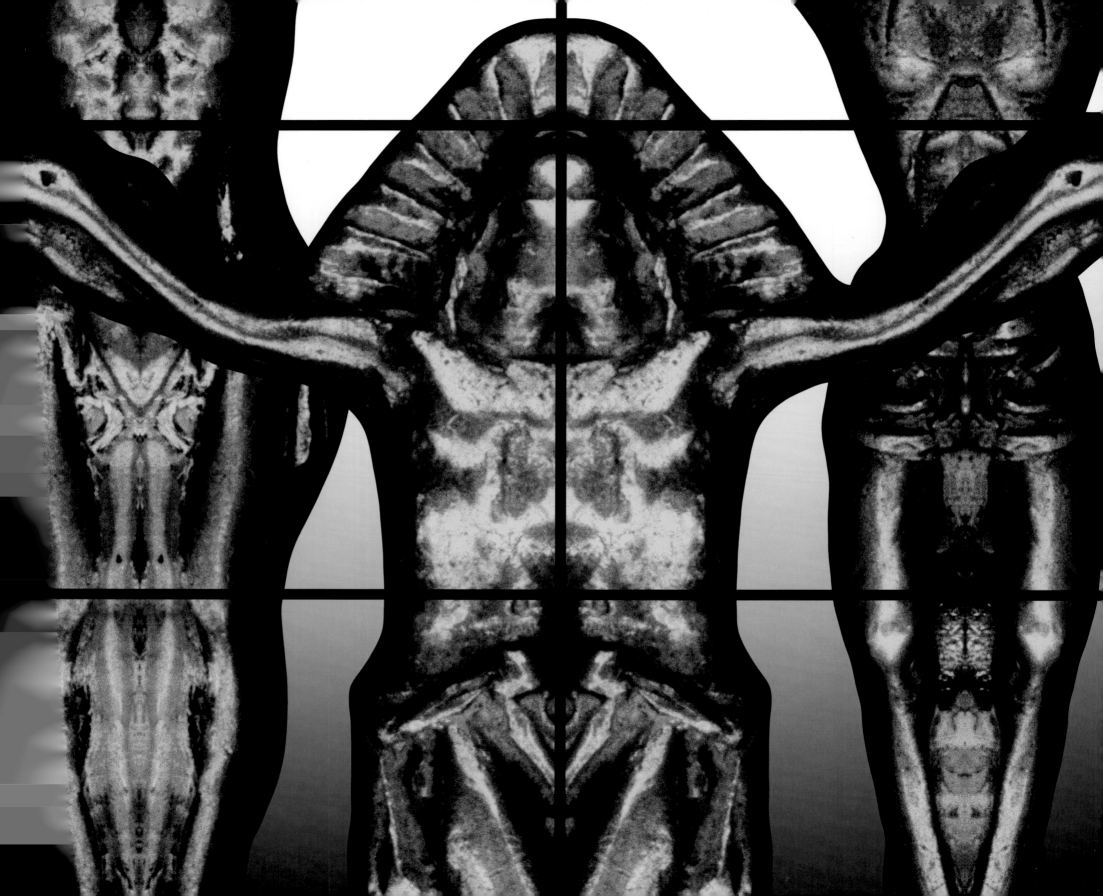

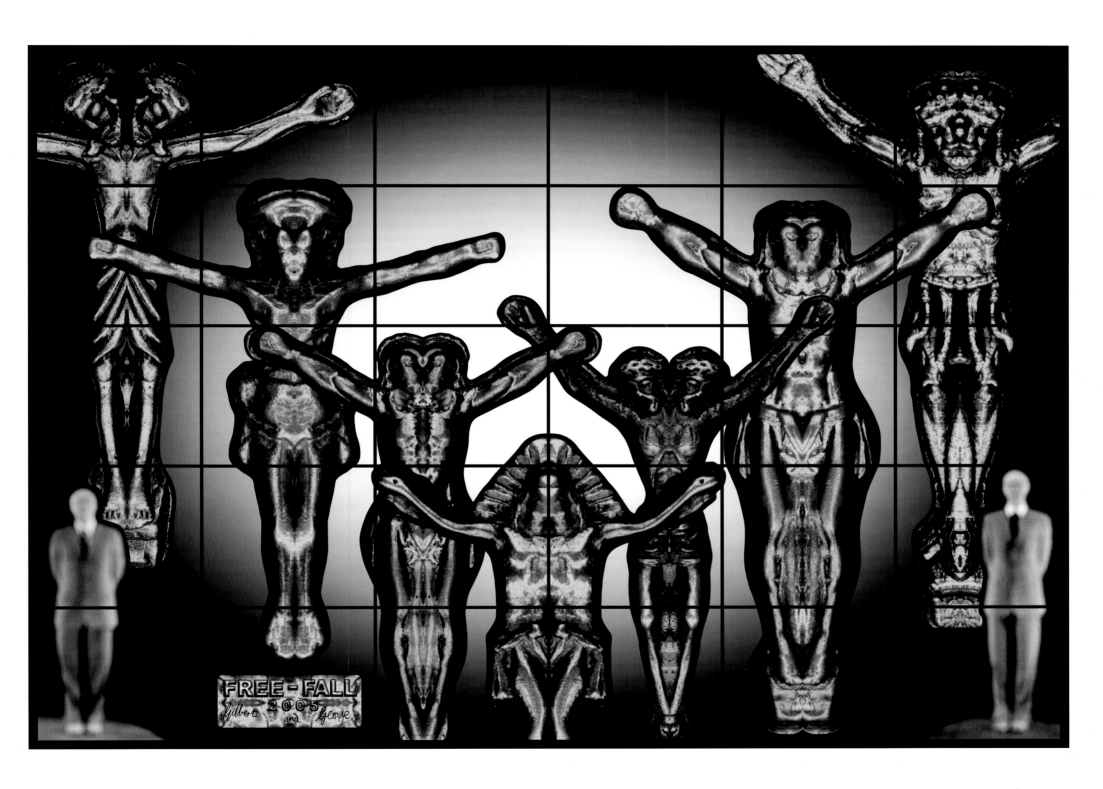

FREE-FALL 2005 318 X 453 cm

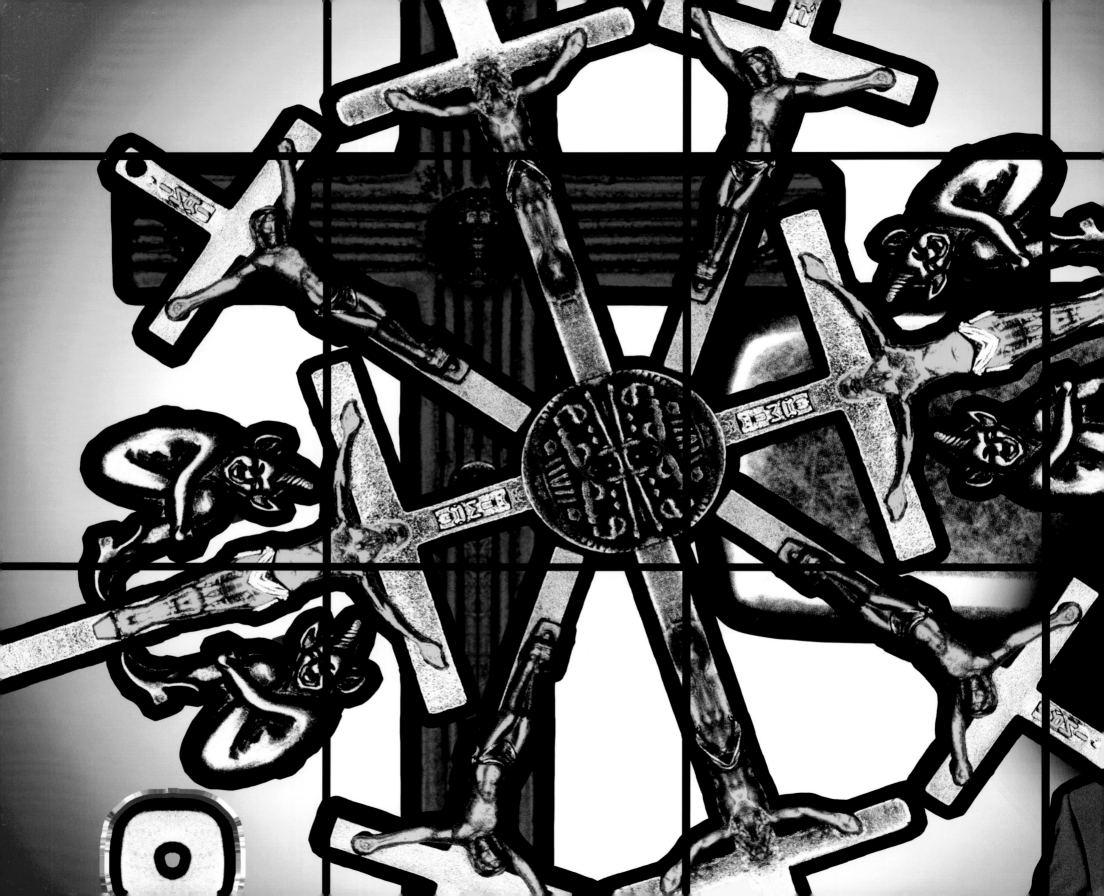

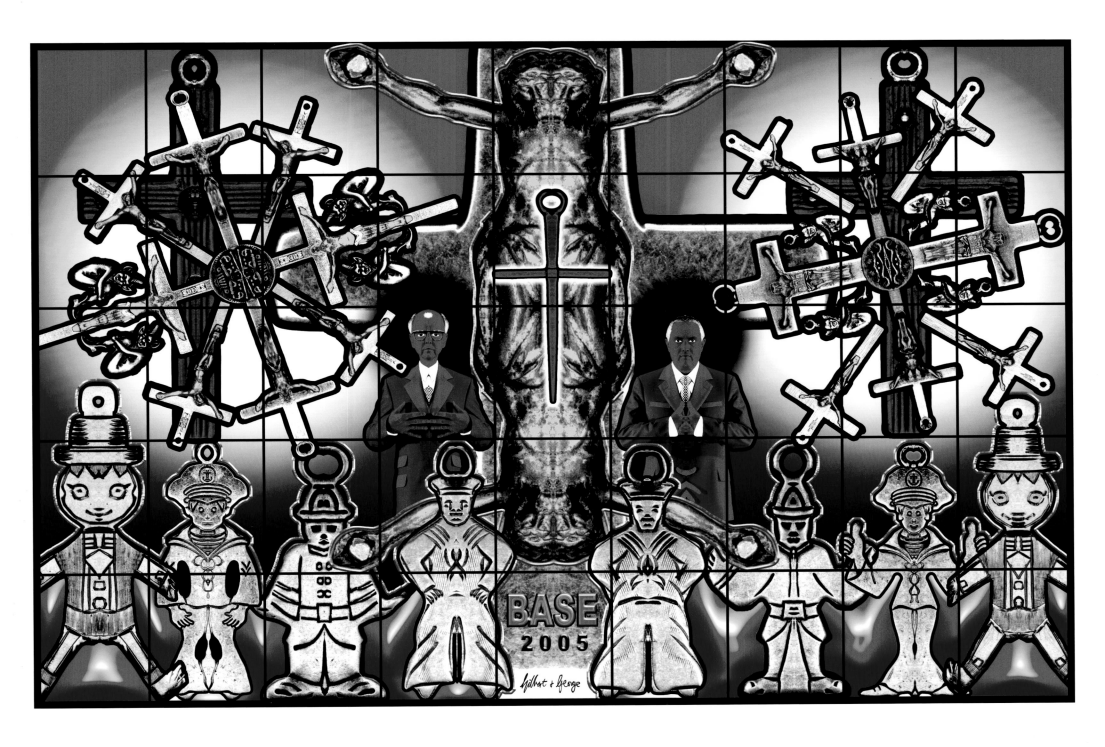

BASE 2005 378 X 572 cm

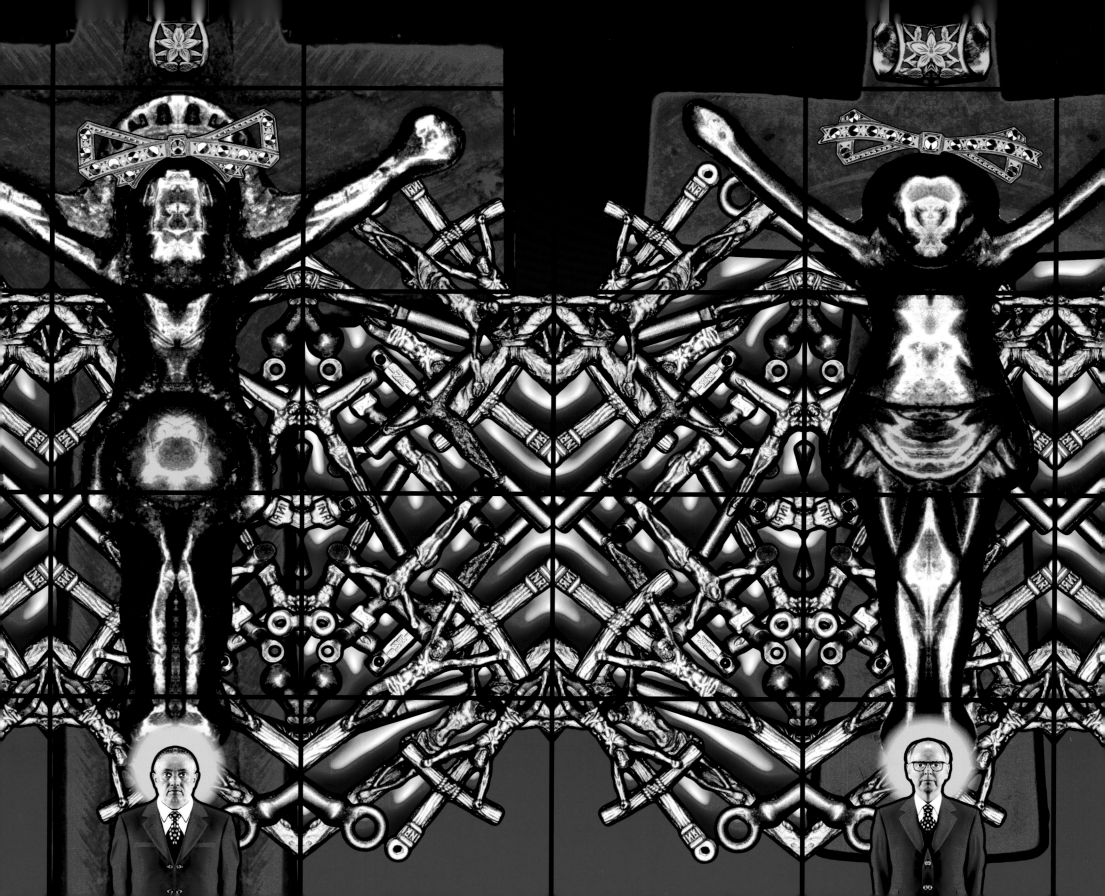

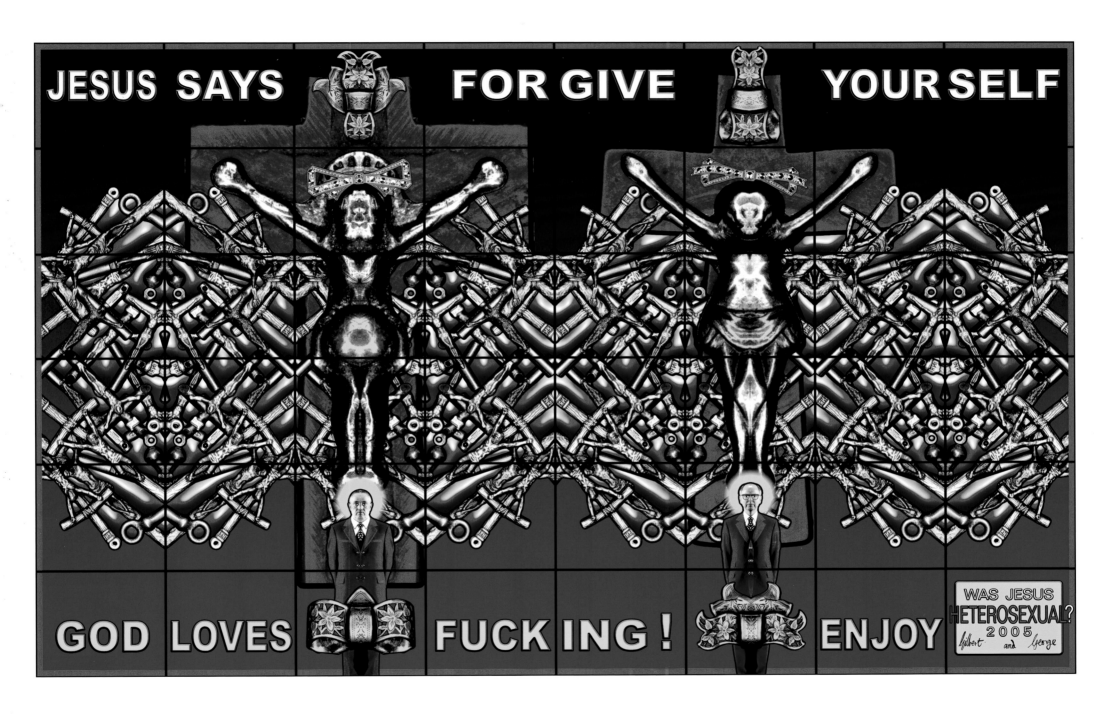

WAS JESUS HETEROSEXUAL ? 2005 381 X 604 cm

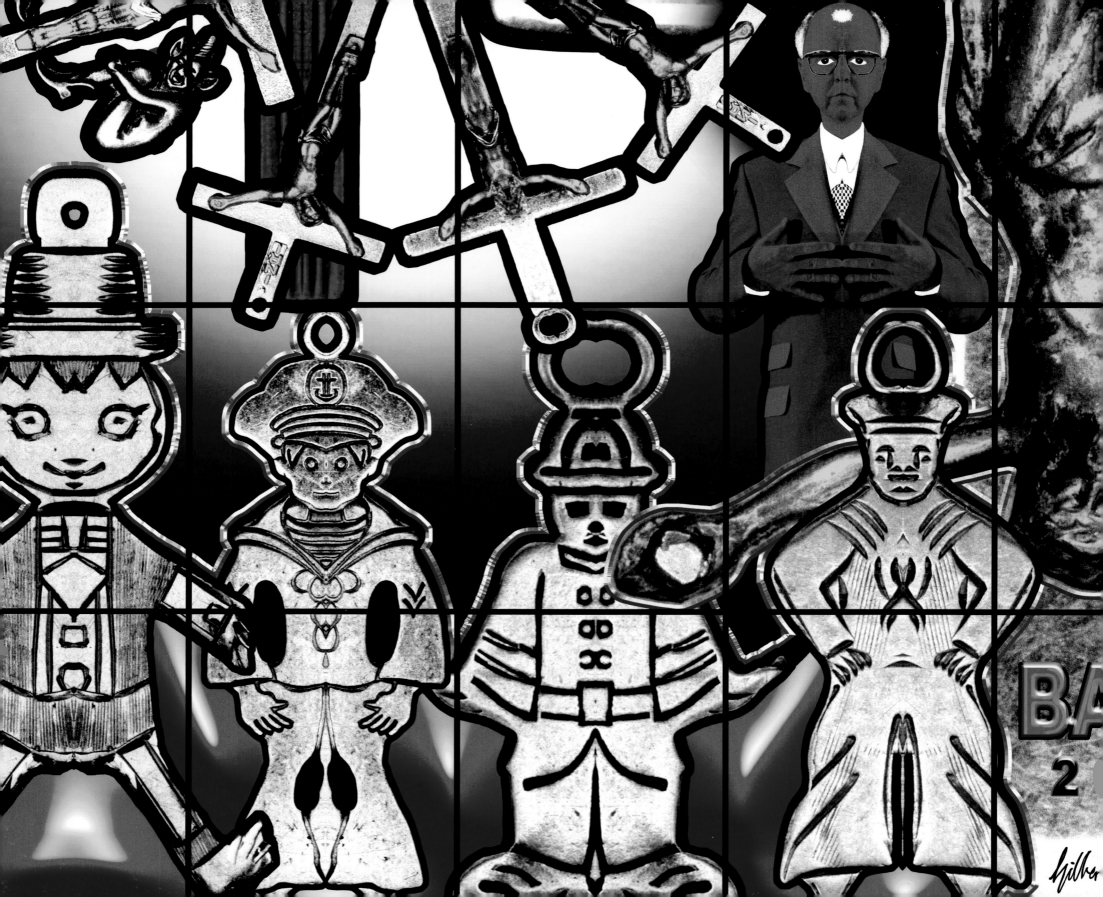

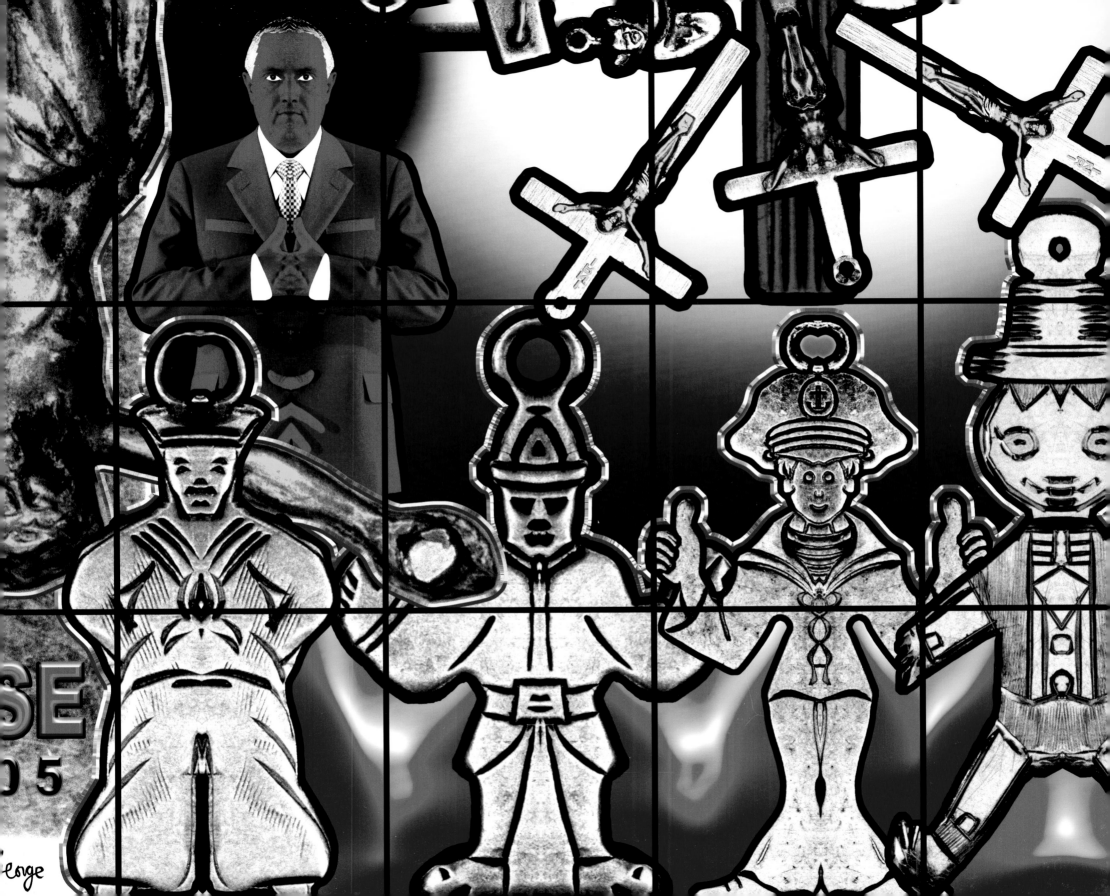

Published to accompany the exhibition

Gilbert & George
SONOFAGOD PICTURES
Was Jesus Heterosexual?

20 January – 25 February 2006

Text © 2006 Michael Bracewell
Printed by Beacon Press

Jay Jopling/White Cube
48 Hoxton Square
London N1 6PB
United Kingdom
Telephone + 44 (0)20 7930 5373
Fax + 44 (0)20 7749 7470
www.whitecube.com

ISBN: 0-9550499-3-8